Bairns

SCOTTISH CHILDREN IN PHOTOGRAPHS

Iona McGregor

Photographs selected by
Helen Kemp and
Liz Robertson

Captions by
Dorothy I Kidd

NATIONAL MUSEUMS OF SCOTLAND

National Museums of Scotland
Chambers Street, Edinburgh EH1 1JF

First published 1994

ISBN 0 948636 61 0 (hardback)
ISBN 0 948636 65 3 (paperback)

British Library Cataloguing-in-Publication Data
A catalogue record for this book is available from the British
Library

Printed and bound in Great Britain by Butler & Tanner Ltd,
Frome and London

Front cover: A pedal car driven by a delighted Norman in a back
garden in Currie, 1920s-30s.

Back cover: The Jenkins family holidaying at Millport, Great
Cumbrae, about 1907. *George Jenkins*

CONTENTS

Acknowledgements

The photographs in this book are from the Scottish Ethnological Archive in the National Museums of Scotland. Most of the Archive's photographs have been donated to or purchased by the Archive, or lent for copying by the owners. A few were copied from the photographic collections of other institutions. The Archive aims to record and preserve documentary and illustrative material as context to the social history collections of the National Museums, and provides a research tool for museum staff and public alike. The collection includes photographs, slides, postcards and film; drawings and maps; audio tapes; manuscript sources such as diaries and account books; newspaper cuttings, bibliographies and notes from documentary and printed sources. The photographers are always named where they are known, and all known individuals are named. Should anyone be able to identify unnamed people or places, or wish to contribute to the Archive, Dorothy Kidd, its curator, would be delighted to hear from them.

For the photographs
Douglas Allen
Auchindrain Museum
Elizabeth Bevan, Stromness
Biggar Museum Trust
Audrey Canning, Gallacher Memorial Library, STUC, Glasgow
Hugh Cheape, Edinburgh
Comunn Eachdraidh Chàrlabhaigh
Isabel Henderson Cramond
Mrs Jean Cunningham, Kincaple
Mary Docherty
Mary B Drain, daughter of George M Halkett
Dunbeath Preservation Trust
East Lothian Community History and Arts Trust (ELCHAT), Musselburgh
Alexander Fenton
Fife Folk Museum Trust, Ceres
Elizabeth Forbes
Alex Gilchrist, Biggar
Glencoe and North Lorn Folk Museum
Gorebridge and District Local History Society
Miss Margaret Alma Grant
Jessie E Gray (née Rennie), grand-daughter of the family on p29
Capt Hay of Delgatie
Andrew D Hodge
Hulton Deutsch Collection Limited for the photographs on pp20,47
Billy Kay

Kinross-shire Historical Society
Eira Langler
Lothian Regional Council, Department of Education for the photographs on pp55,60,62-65, 67,68,71,72,78,84,91,113,114
Lothian Regional Council, Department of Social Work
MacGrory Collection, Argyll and Bute District Library Service
Dr Ed Miller, Austin, Texas (whose doctoral research focussed on the Davidson family, see p107)
Nairn Fishertown Museum
Mrs Margaret Reid
Barbara Robertson
Jean N D Robinson
Mrs Joyce M Sanderson (Dr C W Graham's Collection)
Ida D J Sandison
Scotsman Publications
Scottish Labour History Society
Margaret Fay Shaw
Eric Simpson
Dorothy Slee
Jean G Stirling
Tain and District Museum
Tong Historical Society
Urras Eachdraidh Nis
Dr Bruce Walker
Louise Wilson, daughter of the photographer Frank Wilson
Graeme Woolaston
Morven Wright

For kind permission to reprint extracts from their books:
Jean Faley *Up Oor Close* White Cockade Publishing 1990
Save the Children *A Scottish Childhood* eds A Kamm and A Lean 1985
Anna Blair *Tea at Miss Cranston's* (1985), *Croft and Creel* (1987) and *More Tea at Miss Cranston's* (1991) all published by Shepheard-Walwyn (Publishers) Ltd
Tollcross Local History Project *Waters Under the Bridge* 1990

The following people also provided a great deal of additional information: Louise M Boreham, Hugh Cheape, Mary Docherty, Dr David Hutchison, Hamish D Leal, Lothian Health Board, Mrs S Macdonald, West Lothian NHS Trust, David Munro, Joyce M Sanderson, William L Scott, Margaret Fay Shaw, Dorothy Slee, Mrs Ann Stanton and Morven Wright.

We would also like to thank the following colleagues for their help, advice and expertise: May Goodall, Helen Kemp, Doreen Moyes, Liz Robertson, John Shaw, and Gavin Sprott.

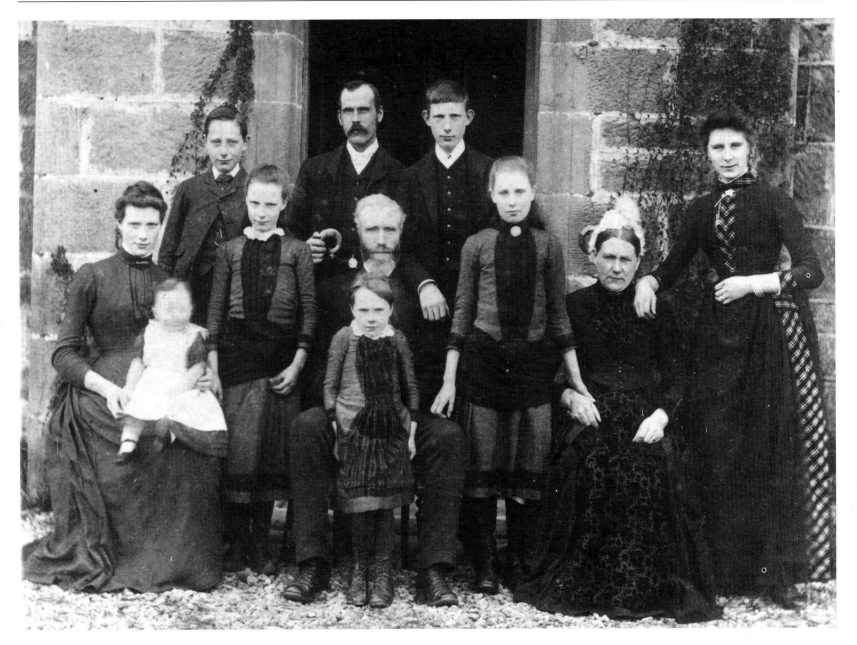

John and Mary Grant (née McGillivray) who farmed at Inverlaidnan, Carrbridge, Inverness-shire, photographed about 1887 with seven of their nine children, a son-in-law and a grandchild. From left to right they are :(back row) Donald McGillivray Grant; Major Alexander Cumming who farmed at Mains of Curr, Dulnain Bridge; William Grant; (front row) Margaret Grant (Mrs Cumming) holding baby Elspeth; May; John with daughter Alice; Flora Jane holding her mother's hand; Mary Ann. The two missing children are Bella and Jessie.

CAMERA'S EYE-VIEW

With joy unfeign'd, brothers and sisters meet,
And each for other's welfare kindly spiers; ...
The Parents partial eye their hopeful years; ...
The Mother wi' her needle and her sheers,
Gars auld claes look amaist as weel's the new;
The Father mixes a' wi' admonition due.

Robert Burns *The Cotter's Saturday Night*

Children are seldom photographed while absorbed in their own pursuits. The adult behind the camera generally decides how they will present themselves, and even the more spontaneous shots made possible by modern shutter speeds will reveal some degree of manipulation. From the timeless portrait of the baby kicking on its blanket (p11) to the girls learning self-reliance at an outdoor centre (p70) the photographic images of childhood are to some degree always controlled by adults.

Unless they are shown as members of a group young children are usually recorded by a parent or other relation. We, the viewers, see them on their own, but their eyes clearly show interaction with the invisible photographer. They are engaged in a family ritual and the photograph itself is a statement on the nature of kinship. Despite the exceptions, it is striking how similar children's poses remain over the years. The Graham brothers (p14) of 1898 wearing identical knickerbocker suits are duplicated in 1955 by Angus and Patrick Cheape (p18) in their knee socks and shorts. The precociously elegant Nan and Tibbie (p15), smothered in their Sunday best against a studio landscape, convey the same message as the two little girls of 1951 (p19) cheerfully unbothered by knee plaster and twisted ankle-socks. The reason is that all parents have essentially the same aim — to give permanence to some moment seized from the rapid transit through childhood. These are their offspring as parents would like to see them: obedient, affectionate towards each other, clean, and predictable. In this first group of photographs only the Mackay brothers (p16) step out of line; their restlessness is hardly suppressed, their grins are full of embarrassment, and mischief is lurking only a minute away.

The trappings that surround the subjects can send complex messages about family aspirations, attitudes and interests, as well as solving the practical problem of keeping the children still. Dorothy Slee (p16) supports herself by holding on to a solidly

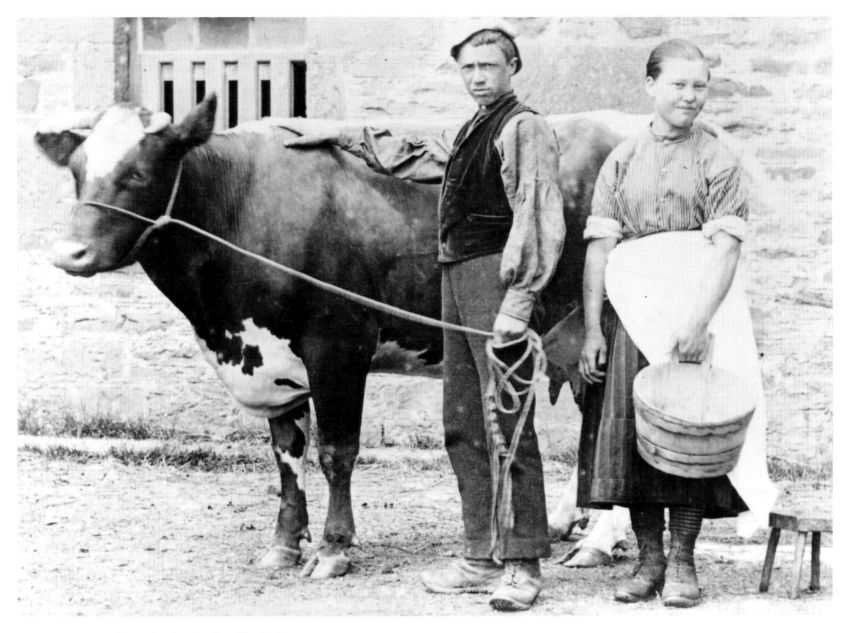

Young herd and milkmaid at Tail
Farm, near Crieff, Perthshire in the
early 1900s.

dependable chair; another little girl (p12) could be wearing a miniature version of her mother's clothes; three-year old Willie Sinclair (p14) has his future as well as his father's crook clasped in his hands, while Tommy Buchan's full-sized driving club (p16) may betray his father's secret hopes. Such incongruities appeal to some people, while others find them cloyingly sentimental; perhaps there is also a streak of unconscious superstition at work, trying to ensure the child's survival into adulthood. Modern adolescents, with their youth culture and attractive, purpose-made clothing differ far more from their predecessors than do younger children. Looking at old photographs it is hard to guess the ages of the girls standing beside their gutted herring or of the boy footballers with their moustaches and quaintly long shorts. They closely resemble their parents in both dress and manner, a phenomenon seen also in the black-and-white films of the Forties and early Fifties. These photographs show young people whose childhood was brief by our standards; many of them had to join the adult workforce from an early age, victims of the struggle between educational progress and economic necessity. In fact, the appearance of teenagers as a separate social group is comparatively recent, if some of their behaviour patterns are not. Janet Hamilton, the Victorian poet, wrote scathingly about 'Geordie, Tam and Rab' who

> Wi' no ae hair on chin or cheek,
> Gang puffin' out tobacco reek;
> In bed at twal' instead o' ten,
> An' think that swearin' mak's them men.

The protective enclosure of young children gives way to a more tenuous control in adolescence; while confirming that universal pattern, these photographs also illustrate the vast changes that have occurred in family life since the mid-Victorian period. The Victorians felt great reluctance to meddle with the family and its internal affairs, yet all levels of society had a clear idea of its function. Since that era more and more laws have been passed to control relationships within the family, although there is much less certainty about its role and nature. In theory we are better equipped to cope with the results of breakdown; but few of today's children live in the kind of extended family that used to exist as part of a close-knit, supportive community. The contemporary nuclear unit is highly conscious of its right to privacy; yet its image is largely the product of media whose voices sound increasingly alike in our shrinking global village. For us the media are our community.

The rigid class structure of the Victorians provides another striking difference between their society and our own. The merging of social groups probably began with the effects of the First World War, although it was not noticeable until after the Second. Before then class was a greater divider than it is today, however much researchers may try to slot us into economic categories. Traditional ways of life also

promoted self-containment, in cases like travellers and the coastal fishing families, while the expense of travel prevented most people from roaming far outside their home area. A few miles away might be foreign territory. All these factors shaped the lives of adults and necessarily had an impact on their children.

The setting up of the Welfare State in the late 1940s gave many people their first chance to take control of their lives. Before then, sibling place in a large family could determine a child's future as much as bad housing and unemployment, which defeated even the most conscientious parents. Those in more prosperous circumstances had a better start, but the health risks were almost equal. Until the advent of modern drugs all children were exposed to infectious diseases that could carry them off before adolescence. Sir Walter Scott was not sure how many brothers and sisters he had had in childhood; there are people still alive who can say the same. The general standard of health and fitness is undoubtedly much higher than it was a hundred years ago; death by starvation is almost unknown in our modern society. Yet an abundance of food does not always go hand in hand with good nutrition, and the nation's diet has deteriorated since wartime austerity. Children today have opportunities that their grandparents never dreamt of, but most of them do not enjoy the same access to fresh air and healthy exercise. Equalisation of opportunity is another factor for change, fusing the once entirely different expectations made of boys and girls.

Apart from recording the physical minutiae of children's lives, photographs can tell us how they are inducted into adult skills and how we hand down our social traditions. The best images can recall the intense reactions of our own childhood. Universal fears and perceptions are worked out in children's lore: hence the power of folk and fairy tales, the cruel tricks played on witch or ogre neighbours, the grannies so implausibly remembered as all-powerful and all-benevolent. Adults are often astonished when they revisit the areas where they grew up. The buildings have dwindled, the woods are only knee-high, exactly like those in a thousand other places we drive through with indifference. What is missing, of course, is the x ingredient — a child's imagination.

> In the winter when you came home from the school and it was gettin' dark, you used to dawdle in the street for fear the close was all ghoulie and dark. Then you used to see the learie goin' into the close and run to watch him pokelin' up his flame-stick to the gas mantle and yon sort of greenish light comin' sputterin' and floodin' the close and chasin' away the shadows. And then it was safe to go up the stair. [1]

[1] Blair, *Tea at Miss Cranston's*, p70.

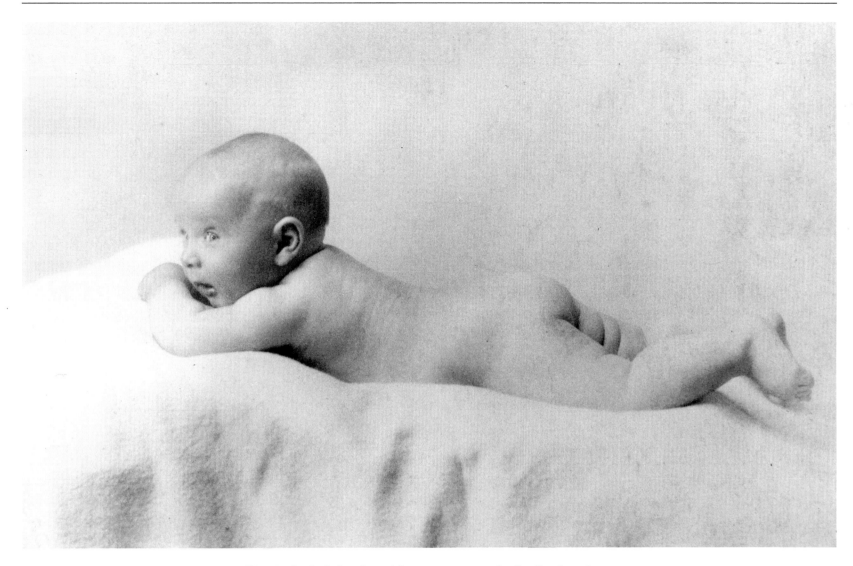

William Hall of Edinburgh aged five months, in August 1925. The message on the back of this photograph, printed as a postcard, reads: 'With fondest love and kisses from Billy to his auntie Nance'. Traditionally babies' photographs are taken without clothes — is this a wish to reassure family, friends, and parents themselves that the baby is healthy and physically perfect? Like countless children, Billy no doubt wished this picture had never been taken, and that his parents didn't keep embarrassing him by showing it off!
Bramwell and Ferguson, Edinburgh

Very serious three-year-old Carsina
Gordon Gray. Born on 25 February
1878, she was the only child of
Charles William Gray of Carse and
Susan Helen Guthrie. Her unusual
name derived from her family home
in Angus; the practice of adding -ina
to a boy's name, or to any word, to
change it into a girl's name seems
uniquely Scottish. The habit is dying
out, but rare examples can still be
found in obituary columns. Carsina
died in 1952.

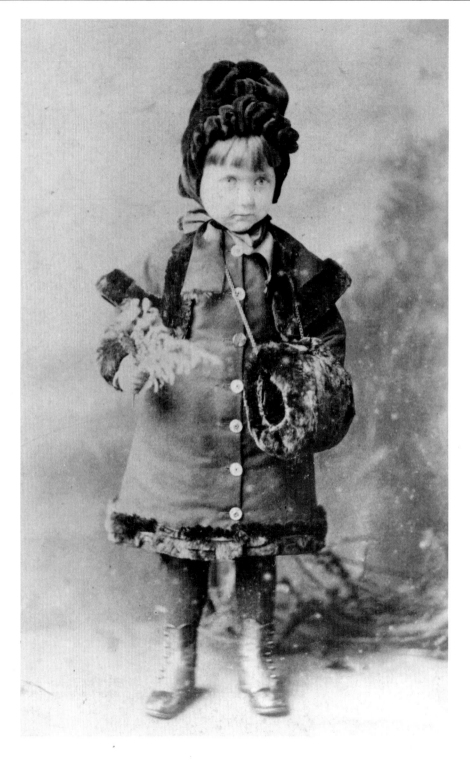

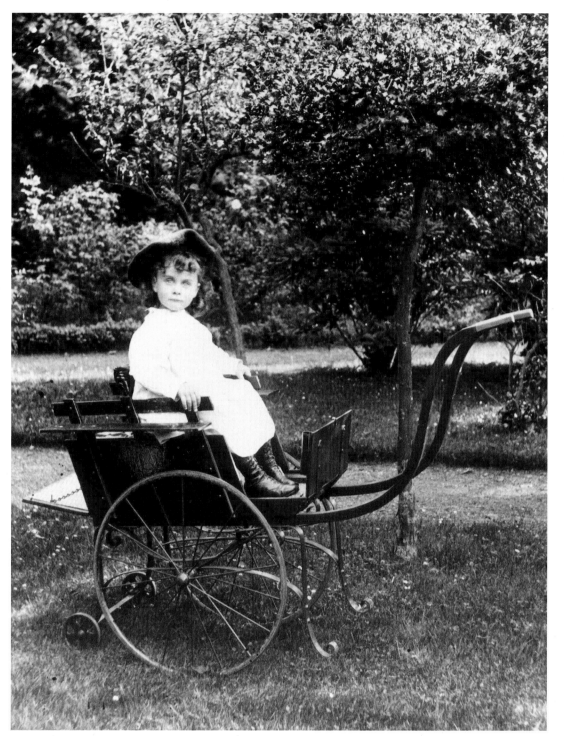

Two-year old Sylvia Stuart (1893-1966) in her push-cart in the garden of her grandparents' summer residence, Mount Esk, at Lasswade, Midlothian. Her little feet are already confined in high-laced boots. Sylvia's father and grandfather were solicitors in Edinburgh. She has a look of over-protected fragility sometimes seen in only children. Sylvia helped her mother with welfare for servicemen during the First World War and was awarded the British Empire Medal.

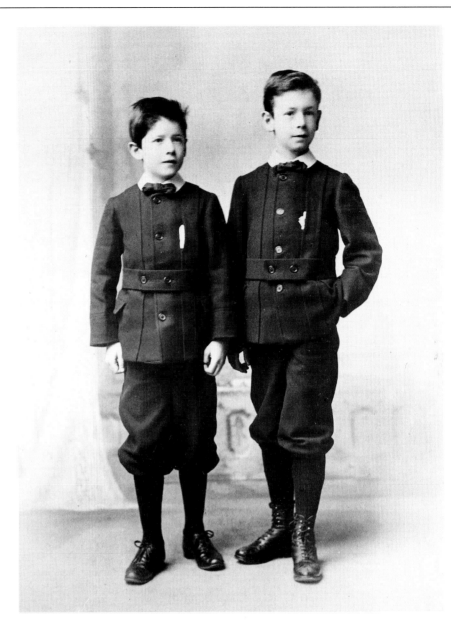

Young Willie Sinclair of Pynagg, Houstry, Dunbeath, Caithness, photographed about 1922 dressed in his sheepskin coat. It must have been very heavy for such a small child. Willie was born in 1919 and was a crofter all his life at Houstry. He died in 1972.

Angelic-looking brothers posing for their photograph in Edinburgh, about 1898. They are George Urquhart Graham and Charles William Graham, sons of Effie Anderson and her husband William Graham of the Union Bank of Scotland.

George later became a Baptist minister and Charles an ophthalmic surgeon and amateur photographer. His photographs of his own children appear later in the book.
Collection of Dr Charles W Graham

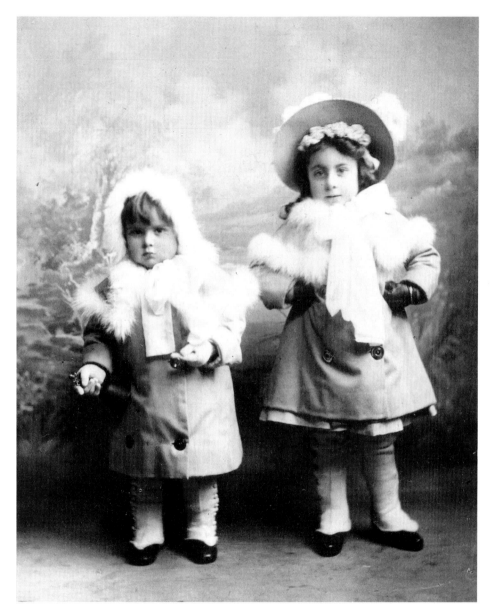

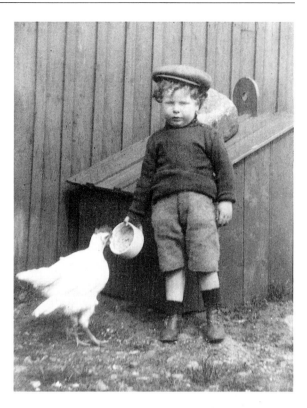

John Crowe of Glenesk, Angus, about 1910 – obviously finding it difficult to feed a hen and pose for a photograph at the same time. He became an engineer and emigrated to Australia.

Agnes (Nan) and Isabel (Tibbie) Cramond of McDonald Row, Edinburgh, about 1902. This posed photograph may have been taken in winter as both are well wrapped up, though the fur trimmings (possibly chinchilla rabbit) were a fashionable addition to outfits. Their father, Adam, ran Cramond's Cab Office off George Square. The company hired out horses and a wide range of cabs and carriages.
C W Sinclair, Edinburgh

Tommy Buchan of Kinnesswood, Kinross-shire seated on 'Maidie's Steps' in about 1920. The steps were named after the owner of the house, Maidie Syme. Even at this late date little boys were still dressed in the same style as little girls until they were 'breeched'. The cheeky young golfer, whose father established the first garage in the village, later became the garage owner himself. *James Scott*

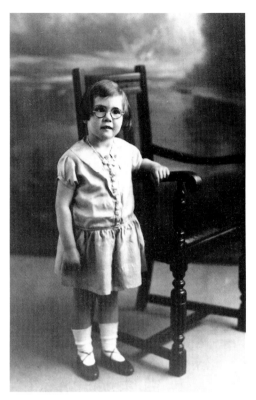

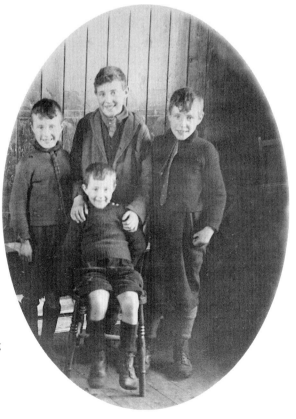

The happy Mackay brothers of Tolsta Chaolais on the west coast of Lewis, Ross-shire, photographed in the 1920s-1930s. They are, standing, Iain, Calum and Ruairidh; with Murdo hiding his hands.

Dorothy Slee of Bellevue, Edinburgh, aged nearly four in June 1932. She was born in September 1928, the youngest of the three children of Grace Logie Murray and William James Slee. William was an engine driver for the London & North Eastern Railway Company (LNER). Dorothy's dress, made by her mother, who made almost all the children's clothes until they reached their teens, is natural tussore silk with pearl buttons.

Dorothy has gone on to write a history of her family: *Two Generations of Edinburgh Folk* (1993) Canongate Academic.

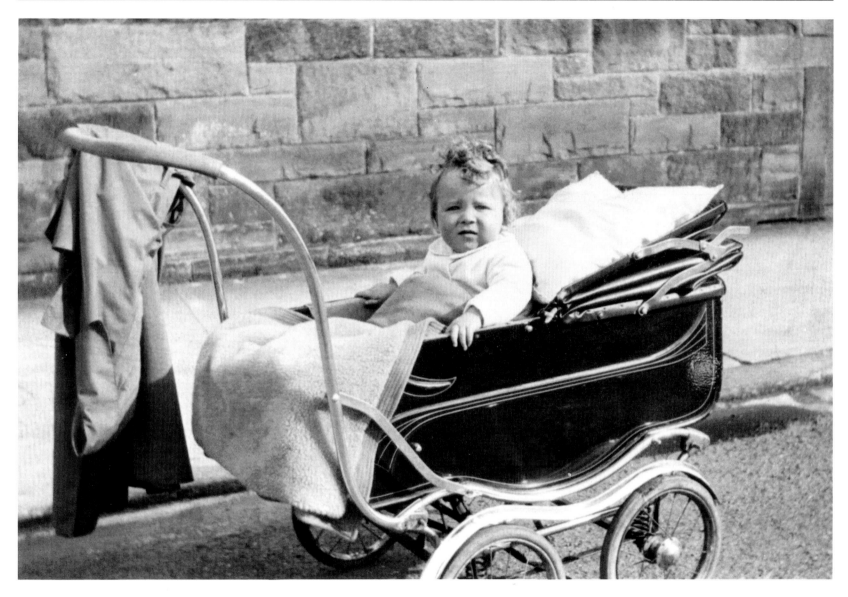

One-year-old Louise, photographed by her father, Frank Wilson, in Bonaly Road, Edinburgh in the spring of 1940. There were far fewer cars on the roads (the number reduced further by petrol rationing) so it was quite safe to leave baby Louise out in her pram.

Louise's mother, Frances, had died suddenly the day before war broke out in September 1939. Frank was determined to bring up his daughter with the help of his mother, but Annie Wilson was nearly seventy and looking after a baby proved to be too much for her. Louise's aunt, Margaret Deuchars, gave up her job as a shop assistant in The Copenhagen in Princes Street to come and look after her. Happily, when Louise was twenty one Frank and Margaret married. They lived to celebrate their silver wedding.

Frank Wilson

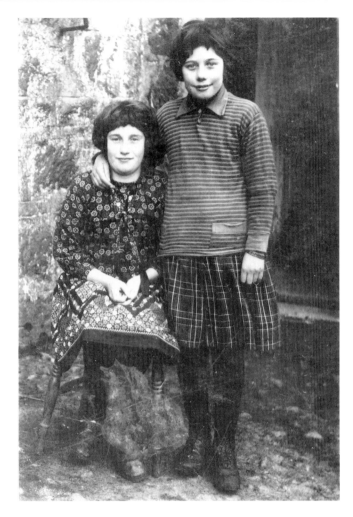

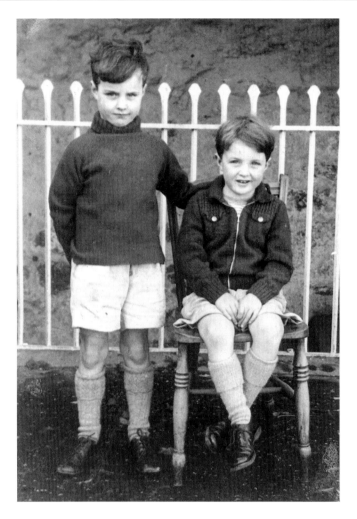

Thirteen-year-old Margaret Martin
with her eleven-year-old sister Nellie
Ann, photographed outside
Amdhantuim School, Lower Shader,
Barvas, Lewis, Ross-shire about
1930.

Brothers Angus and Patrick Cheape,
about 1955.

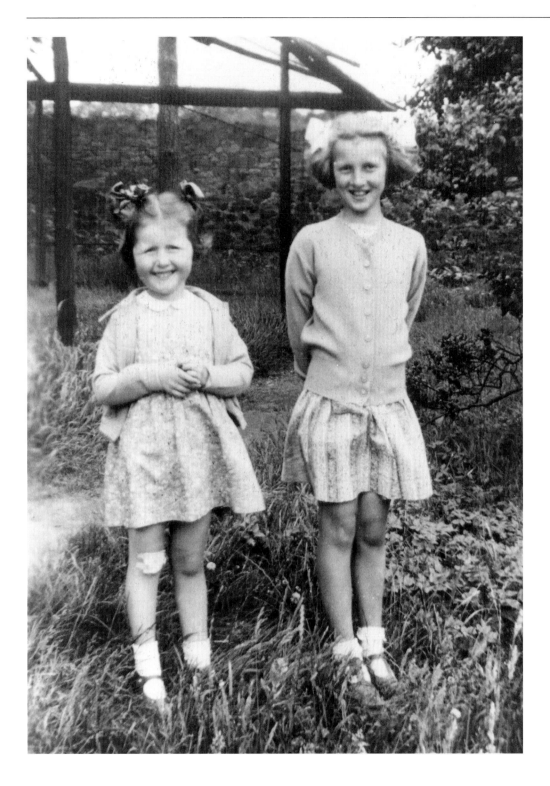

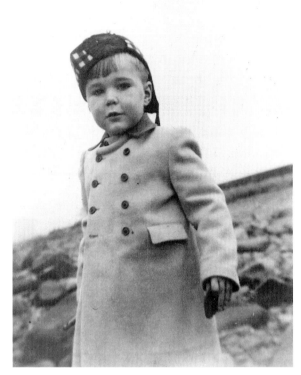

Three-year-old Barry Pringle of Edinburgh, photographed wearing his best camel coat and his father's glengarry by family friend Eira Bauchop, on Silverknowes beach in October 1957. Most of us have argued with our parents over what to wear, but for a brief period parents' desire to show off their children may coincide with children's wish to copy the adults they admire.
Eira Bauchop

Cheerful, but unfortunately unidentified, little girls in 1951. Bobby socks and hair ribbons were the order of the day.

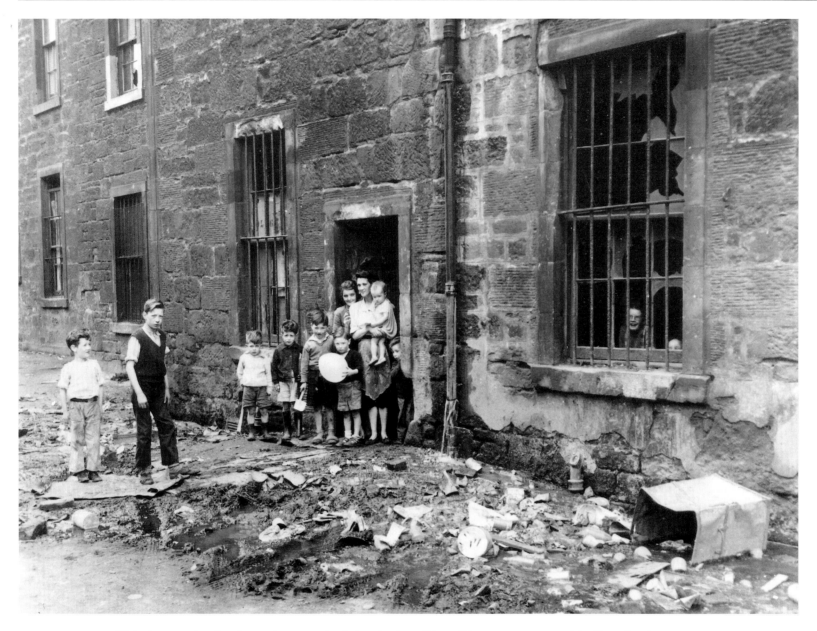

This photograph, taken in 1956, shows a Gorbals tenement shortly before it was demolished. Judging by the looks on the children's faces, a really good place to play. The picture shows not only the squalor that led to the demolition of the Gorbals, but also the solidity of the tenements. Today's planners might have found it preferable (and cheaper) to upgrade the old buildings. The removal of whole communities from the city centre to high-rise blocks and peripheral estates led to social problems that have still to be solved.
©Hulton Deutsch Collection

HOME AND FAMILY

The home and its contents give the most obvious clue to the way a family functions. Before the Second World War most city children would live in a stone-built terrace or tenement, for the habit of semi-detachment did not take firm root in urban Scotland until the 1950s. These tenement apartments varied in size from the grandeur of Edinburgh's New Town to the cramped conditions of the Gorbals single-end. Social aspirations cannot be judged by available space, as we see from Glasgow's Tenement House museum, but in all major Scottish cities over-crowding was the norm. Despite high infant mortality families remained large until the use of contraception became common after World War Two. The only private sleeping arrangements might be a box bed recessed into the wall; sanitation frequently took the form of outside lavatories or a shared cubicle on the landing. In older buildings one tap might have to serve several households.

> Mother and faither slept in the kitchen bed. The three of us girls slept in the old brass bed behind the Room door and the three boys slept in the recess bed that was … in that room too. [1]

Scottish wages were lower than the English average, and late 1930s' unemployment reached a higher peak. There was no general benefit for those out of work; most families had only their contributions to a Friendly Society to fall back on, and these could not be afforded by all. In *Scottish Journey* — a picture of the interwar years — Edwin Muir describes the hopelessness of men he saw loitering in the streets as he travelled through the towns and villages of industrial Scotland. In such conditions, raising half a dozen or more children called for enormous self-discipline. The wonder is that so many families achieved such a difficult task.

Tenement life imposed rigid standards of home cleanliness and co-operation with neighbours in the communal areas of stair, close and wash-house. A skilled housewife could cook on a coal-fired kitchen range almost as easily as with gas or electricity; but without modern devices personal and household hygiene was a mammoth task.

> We always got our bath in a big zinc bath in front of the fire … one of us getting washed and my dad sitting drying us and getting us a cup of cocoa or something after, sitting on his knee. [2]

A weekly bath was held sufficient, and indeed, had to be. To avoid the tedious boiling of kettles, younger children were often dumped in the wash-house 'dolly barrel'.

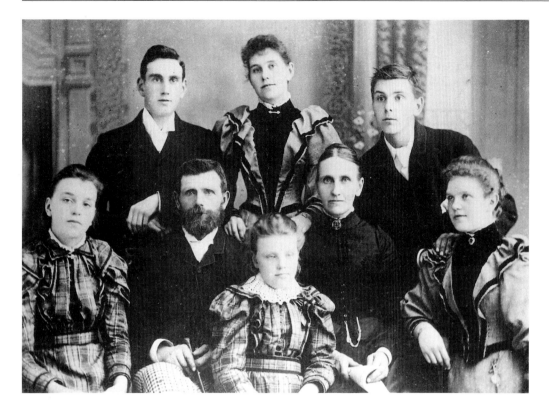

The MacGillivray family who farmed Burg on the Ardmeanoch peninsula in Mull, Argyllshire, in 1901. The children are: Duncan, Neil, Sandy, Duncan senior, Colin, Chrissie and Sarah.

It was common amongst Gaelic-speaking families to conform to naming patterns and to duplicate certain Christian names, as Duncan is duplicated here. The boys would also have had Gaelic nicknames to distinguish the younger (such as òg or beag) or to point to features and characteristics (such as mór, big, or bàn, fair) added to their forenames.
Miss Maudie Cheape

David and Jane Rennie (née Thompson) of St Andrews, Fife, photographed with six of their children in the 1890s. David Rennie ran a builder's business in St Andrews. He and his wife are buried in Balmerino cemetery alongside another son, John, who died aged only seventeen months.

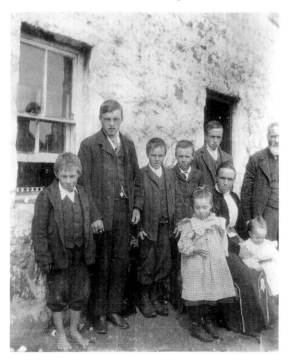

After the Second World War the authorities made a concerted effort to deal with the problems of Scotland's inner cities. There was a mass exit to peripheral tower-blocks and new towns in the Central Belt. No doubt their amenities took a great deal of harshness out of life, particularly for women, yet the move resulted in other kinds of social deprivation: loss of nearby shops and communal support, dispersal of the extended family, and removal of the thousand eyes that overlooked children playing in the street.

By 1945 there were serious housing problems in all parts of Scotland. In the rural coalfields and other Lowland areas tied cottages were maintained, if at all, at the whim of private landlords. The black houses of the Hebrides had not changed much since Dr Johnson's visit in the eighteenth century. Family life all over Scotland was affected by the great burst of post-war building and new regulations defining standards of health and safety. After 1950 the smaller towns began to expand outside their ancient boundaries, surrounding themselves with homogenized suburbs that would not have looked out of place in the English Home Counties. The canny middle classes have rushed back to upgrade the old city tenements. One disenchanted St. Andrean, moved out to a council estate when her family home was converted into a trendy restaurant, grumbled: 'They're puttin aa the workin folk ower the burn'.

Indications of prosperity change over the years. Cheap, well-made clothing began to be available only after the invention of the sewing-machine in the mid-nineteenth century. Before then, those who could not afford a dressmaker made their own clothing at home. Discarded or outgrown garments were adapted for second or even third-hand use. For many families, children's shoes — more usually boots — were too expensive for everyday wear except in winter. In country districts they might be carried to church or school and laced up a few yards from the door. The bare feet seen in old photographs may, however, signify thrift rather than grinding poverty. Formal studio photographs usually show sitters of all social classes posing in their 'Sunday best', a concept that divides then and now as much as our modern plenty of cheap, mass-produced clothing.

> On a Sunday night, after wearing our braw clo'es ... faither's suit went down first (into the chest used as a wardrobe), then mother's cloe's, then Willie's and Jim's, then Maggie's, Nellie's, Bessie's, then George's ... and all the Bibles. In went the mothballs ... After the Sunday School our good shoes got taken from us, all brushed, and polished wi' velvet, then they were put up on a shelf above the lobby door. [3]

A previous chapter is prefaced by an extract from *The Cotter's Saturday Night*. A hundred years after its first appearance in 1786, Burns's poem was still seen as the quintessence of Scottish family life. Its values are universal, but what makes the poem peculiarly Scottish is the way in which the poet elevates the family into a microcosm

of God's order on earth. Even those who fell far short — as did Burns himself — paid tribute to the ideal, which was shaped by the precepts of the national church. Up to the mid-1940s visitors continued to be amazed by the complete cessation of normal life on a Scottish Sunday. Certainly daily home worship had declined by the 1890s, but Sabbatarianism was so deeply embedded in the nation's psyche that only the most free-thinking, or the destitute, escaped its influence. 'Respectability' demanded weekly attendance at church. In the country, defaulters were quickly picked out; in towns, where congregations first began to fall, the older generation remained faithful to the habit even when their bicycling sons and daughters were whizzing past the churches on their way to the country. For those who observed the full rigours of the Scottish Sabbath the only relaxation permitted was a sedate walk between services. It is only since the end of the Second World War that churchgoers have regarded the rest of Sunday as a normal family day.

Upheld by the Church's teaching, another ideal was the patriarchy that dominated Scottish life, however browbeaten or ineffectual individual representatives might be. Dundee women working in the jute mills were frequently the breadwinners for their dependants while the men kept house, but this was considered a national scandal. Duncan Campbell recalls in *Reminiscences of an Octogenarian Highlander* (1910) how, when a tenant died, his eldest son had to

> keep a roof-tree over his brothers' and sisters' and mother's heads, to labour, sweat and struggle, remain celibate, until his brothers were launched on their own careers, the sisters were married.... He generally had his reward in the ... patriarchal position which he had won by self-sacrifice.

Throughout history Scots have been known for their tendency to emigrate. The most able have often sought fame and fortune abroad, as in the mass exit to England. Others have been driven from their native country by poverty. Harsh landlords played their part in the wholesale clearance of Highland areas. But the traffic has by no means been one way. From the 1840s onwards successive waves of immigrants entered Scotland, adding their own family traditions to the Presbyterian ethos. The largest number came from Ireland, driven to their nearest landfall by the potato famine, and most of them were Roman Catholics. Hostility already existing between Protestant and Catholic was aggravated by nineteenth-century fears of cholera and the housing shortage. By the inter-war Depression years the family life of the two sects had became almost identical; the rivalry, though still extant, is less intense nowadays. More exotic incomers were people of Jewish, Italian and Chinese origin, and, most recently, families from the Indian sub-continent. The size of an immigrant community largely determines how strongly it maintains its own traditions, so it is not surprising that these were most markedly upheld in Glasgow, Scotland's largest city. The differences

were most noticeable where the weekly day of rest did not fall on the Christian Sunday.

David Daiches recalls the first time his family called on a message boy from the local corner shop for essential help:

> 'See,' he said to my mother the first time he was asked to come in and light the gas, 'it's quite easy. Ye just turn this wee handle and then pit the light tae the wee holes.' 'I know how to do it', replied my mother calmly, 'but this is the Jewish sabbath, and I may not strike a light.' The boy's jaw dropped ... but later he came to take it all for granted. [4]

Non-Jewish children probably envied their friends as the weary week of lessons drew to a close:

> In winter on Friday we used to get out of school a wee bit early to do all the traditional things (for the Jewish Sabbath). We were sent to Callender's big bakehouse in Hospital Street, where the night before we would've put in the Shabbos dinner ... the 'cholent' ... a kind of traditional hot-pot. Abbie Callender had come to Glasgow as a boy ... The whole family ... delivered bread, schalz herring and wurst in an ancient van to Jewish families all over Glasgow. [5]

For a long time authority was reluctant to interfere with the private world of the family, even when there was patent abuse. Successive regulations from the early Factory Acts onwards invaded this privacy until laissez-faire was overturned in the mid-twentieth century. In the hundred years being examined changes in family life arrived imperceptibly, except during two brief and terrible periods: the World Wars of our own century brought catastrophic upheaval for all children, often without warning. We tend to forget that the 1914-1918 conflict had its own quota of rationing and air-raids — Zeppelins dropped bombs on Edinburgh — but its main effect on the family came through the annihilation of a whole generation of husbands, fathers, brothers, and sons. The events of the 1940s affected children more directly. Among other consequences, it became necessary to evacuate huge numbers of them out of areas likely to become bombing-targets.

Evacuation could be a traumatic experience:

> We'd no idea where we were bound until after the train left Parkhead Cross, and then we were told, 'Perth'. What a journey! Hundreds of mothers, weans and bawling infants packed like herring, and no toilet on the train. [6]

For some city children the sights and sounds of the country were such a culture shock that they headed straight for home as soon as the 'Phoney War' was over.

> We finished up in a small steading ... goats running about in the back yard ... goat's milk in the porridge you could stand your spoon up in ... and you had to ... draw your water from a well ... We only lasted a few months. [7]

Some of the returners were lucky, others not. Newspaper photographs give a harrowing record of the Clydeside blitz and the Luftwaffe's raids on Aberdeen and Peterhead. Even children outside the danger areas experienced gas-mask drill, black-out regulations, and interrupted schooling. No child who lived by the sea could escape the war, even on the far-off west coast of Harris. Donald John MacLennan recalls beachcombing for

> cartons of ... Lucky Strike cigarettes, huge slabs of butter and lard, and ... life rafts complete with survival packs of food ... a small tin of coffee, three biscuits and a couple of cubes of barley sugar. [8]

More dangerous objects were the

> thin, tubular, fish-like objects with fins sticking out of them... and ... golf-ball shaped things with horns... Along would come a high-ranking naval officer to "fix" these mines. The result was the most beautiful bang a ten-year-old ever heard. [9]

For six years the interests of that smaller unit, the family, were absorbed into those of society as a whole. Fathers vanished into the armed services; for many children who are now adults in their sixties, family life in the usual sense ceased abruptly before they reached their teens. Everyone old enough to remember knows what he or she was doing on September 3rd, 1939, just as their own children recall the day on which President Kennedy was assassinated.

> That day was like a kind of terminus to my childhood... I don't mind of ever really 'playing', again. [10]

[1] Blair, *Tea at Miss Cranston's*, p4.
[2] Tollcross History Project, *Waters Under the Bridge*, p12.
[3] Blair, *Tea at Miss Cranston's*, p19.
[4] *A Scottish Childhood*, p54.
[5] Blair, *More Tea at Miss Cranston's*, p215.
[6] Blair, *Tea at Miss Cranston's*, p191.
[7] Tollcross History Project, *Waters Under the Bridge*, p148.
[8,9] *A Scottish Childhood*, p149.
[10] Blair, *Tea at Miss Cranston's*, p189.

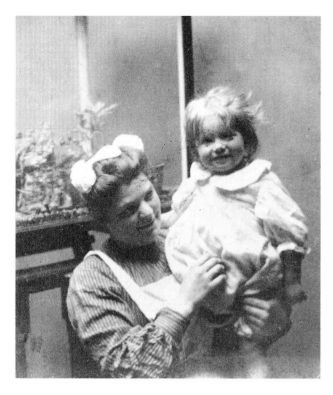

Beth Goalen of Edinburgh in the arms of her nurse. The large vivarium behind them was built by Beth's father for his collection of toads and snakes.

Despite their serious expressions, this is a very natural studio portrait of a mother and child, of about the 1880s. It raises some interesting questions: did the woman or the photographer choose the profile pose? Was the feeding bottle the only way of getting the child to keep still or to stop crying?
James Porter, Perth

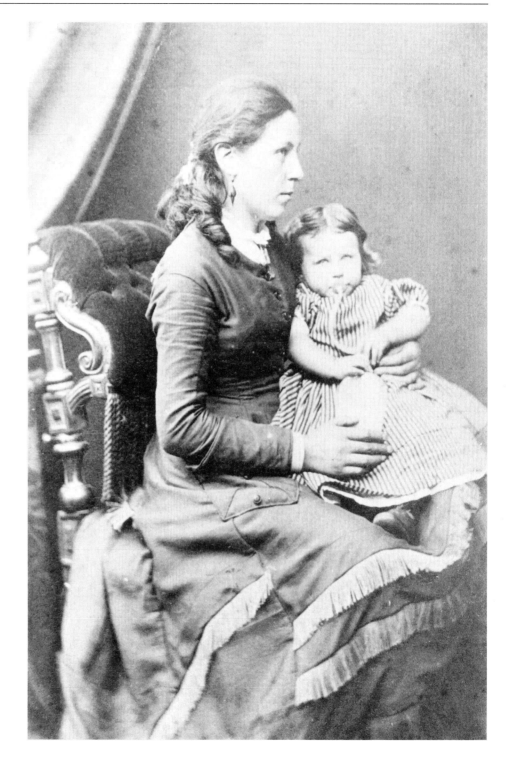

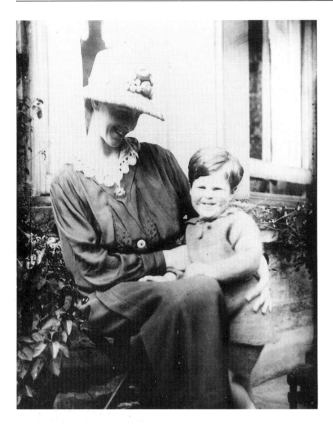

Ian Graham with his mother Ada, who had knitted his jumper and shorts, outside their house 'Viewforth' in Lerwick, Shetland about 1922. The family was from Edinburgh, but Ada's husband Charles, a doctor and amateur-photographer, was practising in Lerwick's Gilbert Bain Hospital at the time. Motherly pride has obviously made Mrs Graham forget the camera.
Dr Charles W Graham

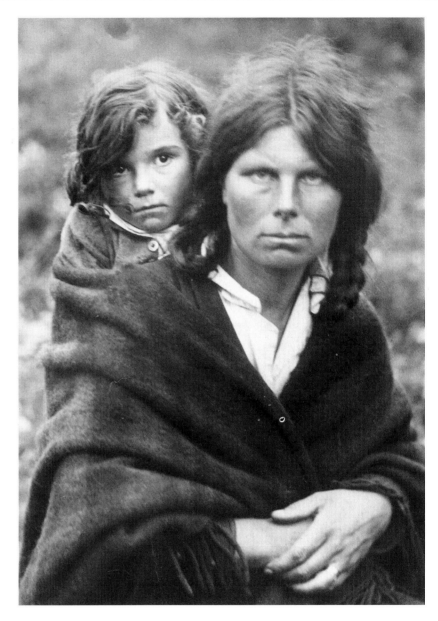

Mother and child from a travelling family, thought to have been photographed in Perthshire about 1932. In contrast to the previous picture, the photographer has not got his subjects to relax.
Hamish Muir

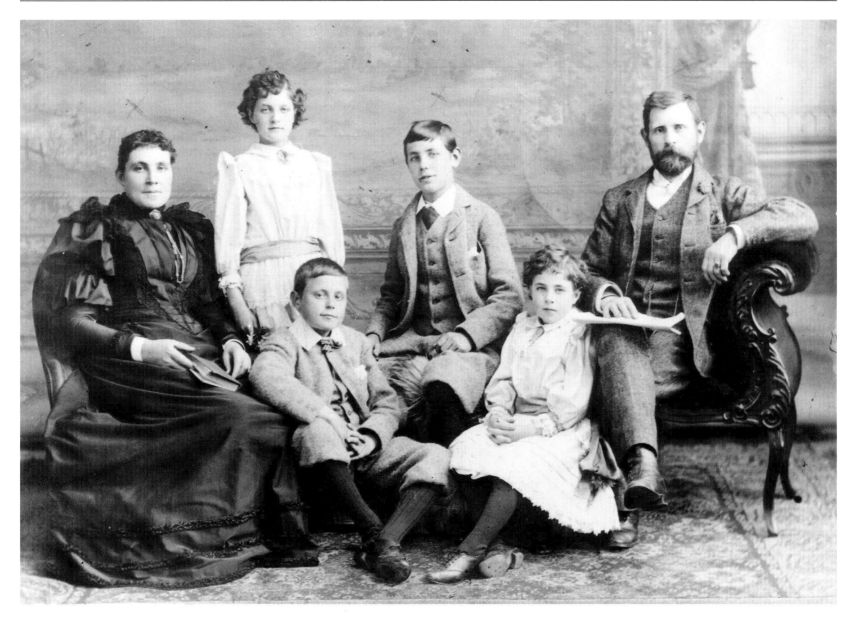

The Rennie family of Edinburgh, photographed about 1890. Mr Rennie owned a busy butcher's shop in Blackfriars Street, just off the High Street. The children are Jessie, Lewie, James and Polly. Polly died while still a child; both James and Lewie 'ran off' to the army. Lewie eventually went on to own the Royal Restaurant underneath the 'Hielandman's Umbrella' (the bridge underneath Central Station) in Glasgow.

Alex Nicol, Edinburgh

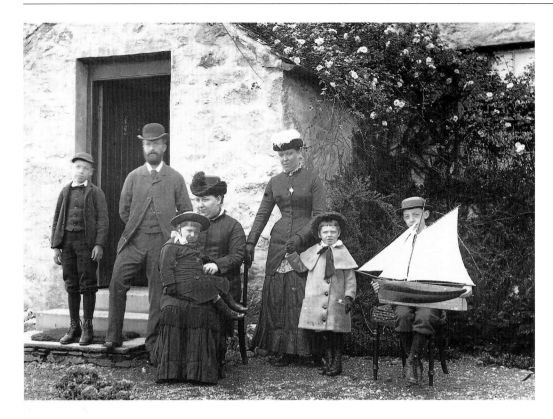

A family group in their best clothes outside a manse door, thought to be in the Ben Nevis area of Inverness-shire, about the 1890s. The sailing boat held with great pride may well have been home-made. The sour expression on the face of the smallest child may be related to the tight grip his mother has on him or to the constriction of his high-buttoned boots.

Arnot, Jim and Robert Jenkins photographed on Calton Hill, Edinburgh by their older brother George, about 1900. The clothes of the brothers show age-related gradations which presumably marked the transition from boy to man.
George Jenkins

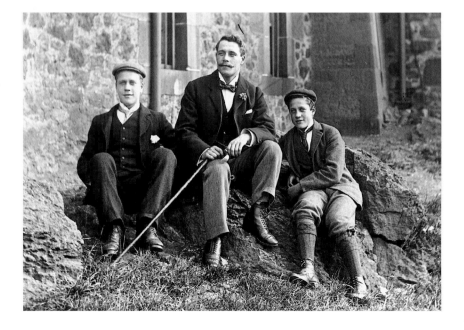

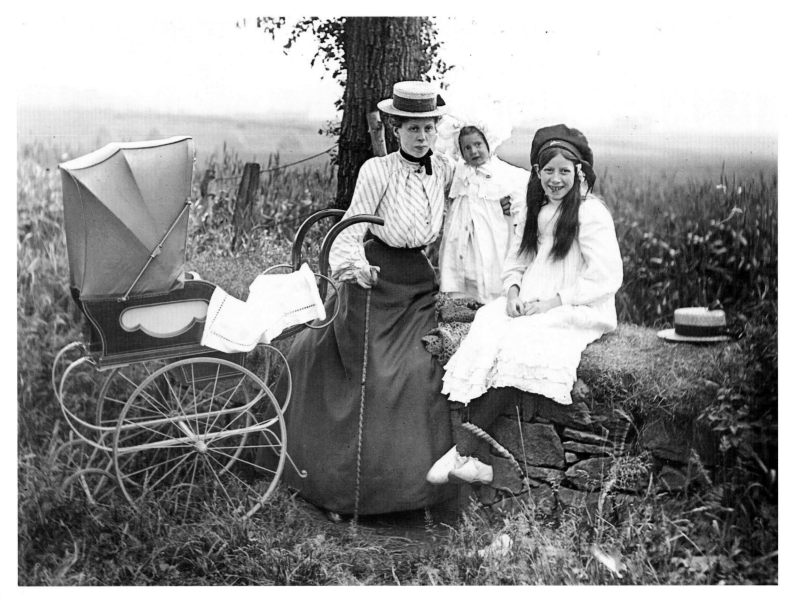

Another family photograph by
George Jenkins, probably the owner
of the spare boater on the right of the
picture. This one, thought to have
been taken at Comely Bank,
Edinburgh, about 1903, is of his wife
Jessie Logan with her sister Bella and
their baby daughter Jean. The pram
looks as though it was one of the
most well-sprung and comfortable
models available at the time.
George Jenkins

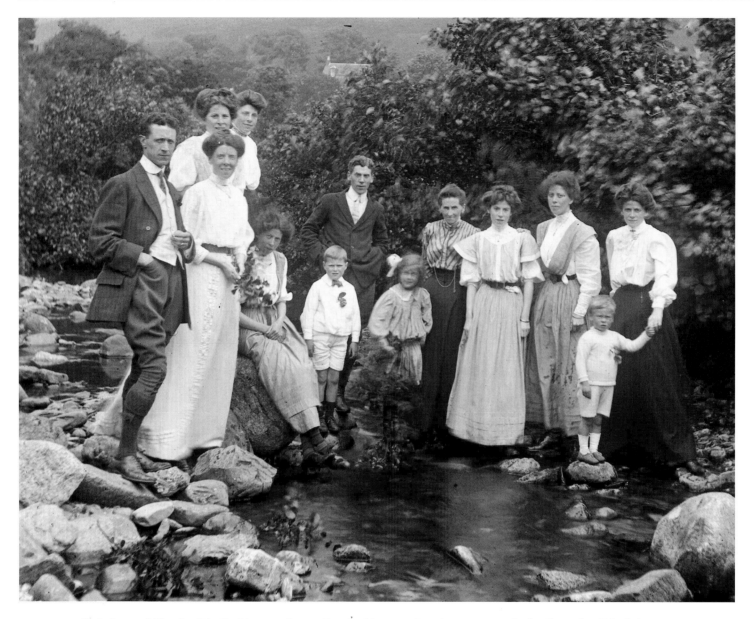

Relatives and friends of the Jenkins family of Edinburgh on a West Coast holiday to Innellan or Tighnabruaich in about 1908. They are Willie Kidney, aunts Agnes, Mary, Sally and Bella; cousin Wallace (Sally's son), uncle Jim Logan, Jean Jenkins, grandmother Logan, aunts Meg and Jean, George Jenkins junior holding the hand of his mother Jessie Logan. No-one is dressed casually, despite being on holiday; the man on the left is in country tweeds but still wears a high starched collar and polished city shoes.

Jessie Logan came from Glasgow and many Jenkins family holidays were spent on the west coast with members of her very large family.

George Jenkins

Three-year-old Francis and five-year-old Patrick Matthew of Edinburgh, photographed with their uncle Charles Matthew, probably on holiday in Perthshire in 1902. Their father owned the Victoria Rubber Works in Leith Walk.

Francis is all set to play gird and cleek by guiding the hoop along for as long as possible with the hooked iron stick.

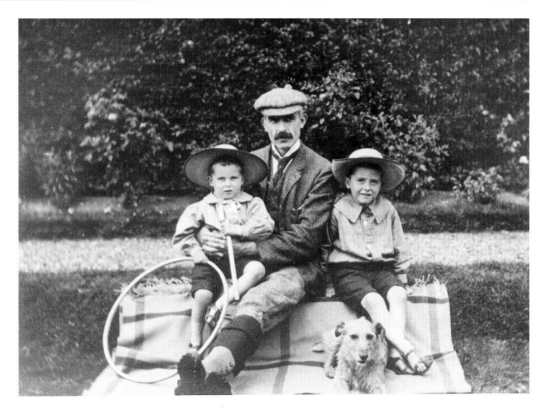

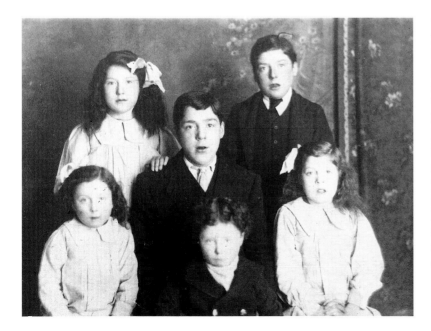

The Drummond children of Edinburgh's Cowgate, photographed in 1917 at the request of their father, a brushmaker, who had been called up into the Army and missed them. They are, back: Margaret, James and Henry; front: Agnes, Thomas and Mary-Anne. Early studio portraits had a strong relationship with contemporary portrait and genre painting, but a flourishing industry soon sprang up in cartes-de-visite (3½ by 2½ inches) which performed the same function as had silhouettes or miniatures before the age of photography.

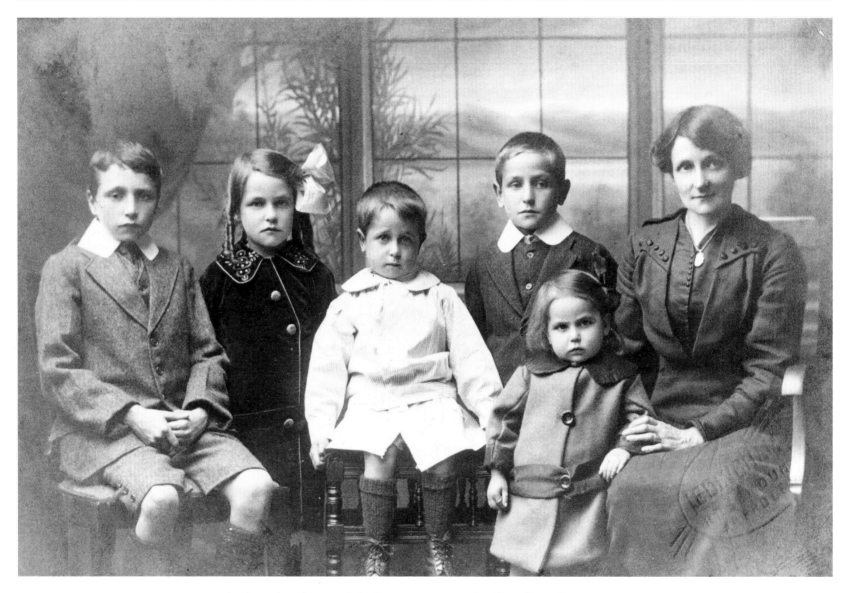

Sarah Mathers (née Brodie) of Aberdeen with her children Jim, Carrie, Joe, George and Jessie in about 1917. The photograph was probably taken to send to their father George 'Dod' Mathers who was serving on the Western Front in France at the time. The low-belted coat Jessie is wearing seems to anticipate the 'flapper' fashions of the 1920s.

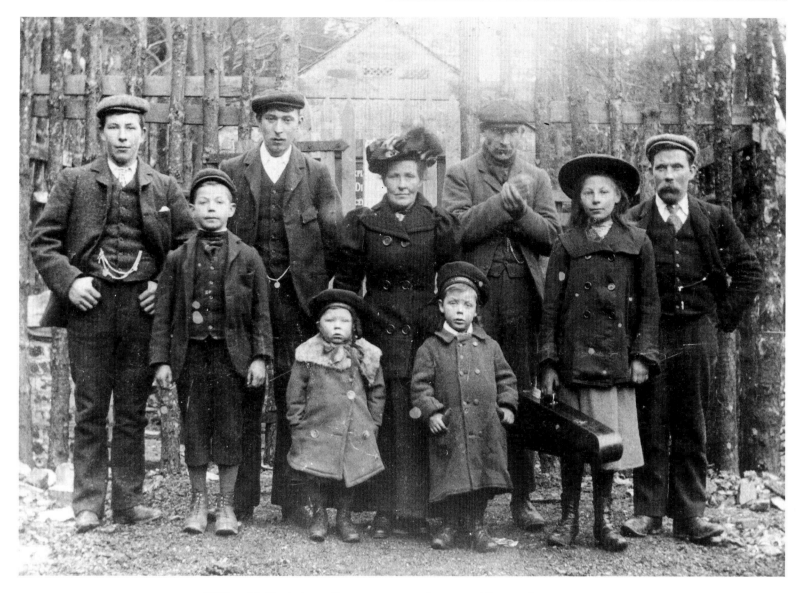

William McHardy is standing very erect second from the left with members of his family, including his fiddle-player sister, in Angus, in the early 1900s. The men in jackets, waistcoats and 'bunnets' are irresistibly reminiscent of Pa and Grandpa Broon from the famous Sunday Post family.

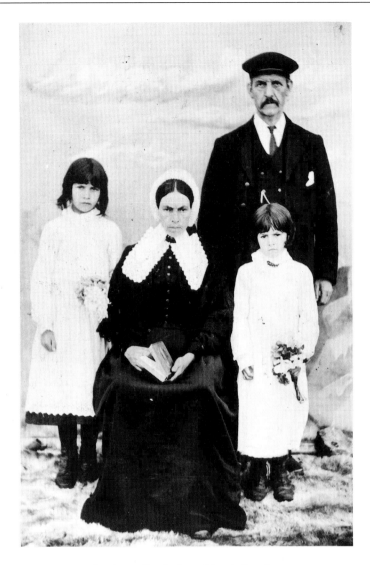

A solemn family from Ness in Lewis, Ross-shire, photographed in their best clothes in the 1880s. It is hard to believe that these are parents, not grandparents, but their aged look may reflect the harshness of their lives. The mother is wearing an elaborate collar and holding a book of 'Devotions' or 'Book of Days' which might have been a studio prop but which fits perfectly with the atmosphere of the picture.

The MacKay family of 23 Aird Tong, east of the village of Tong near Stornoway, Lewis, Ross-shire in the early 1930s. They are, standing: Mrs Stephen (nee MacKay), an aunt who was visiting from Toronto in Canada, Alisdair MacKay; seated: John MacKay, Annie MacKay and John Angus MacKay.

A travelling family, possibly in Midlothian about 1900, from a post-card posted in Dalkeith in May 1906. Their costumes give them an exotic Romany look. Only the little boy in the centre is concentrating his attention on the photographer and looking as though he wants the picture to turn out well.

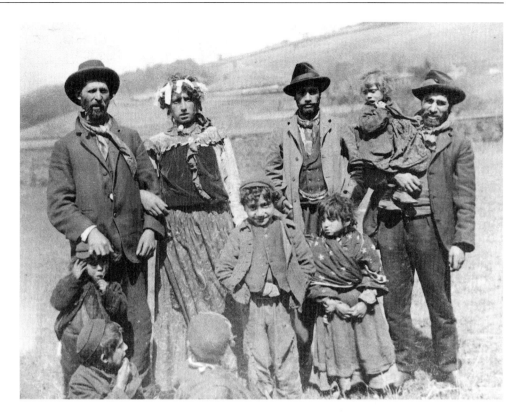

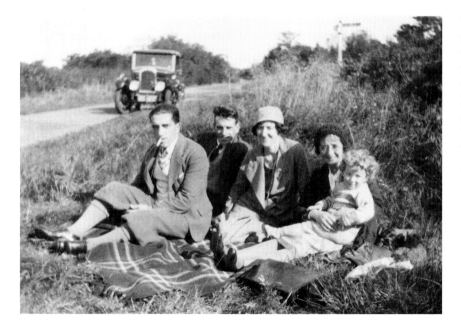

Two Edinburgh families enjoying a roadside rest during a drive, possibly to East Lothian in 1932. They are, left to right, Alex Young, Frank Wilson, Greta Young and Frances Wilson holding year-old Charles Young. The five had many excursions in the Young's car, a Hillman called 'Tildy', which had belonged to Greta's father.
Frank Wilson

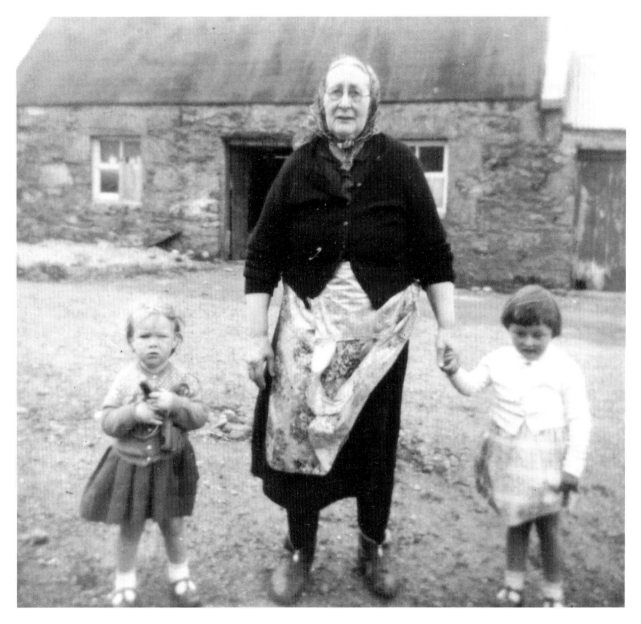

Annchris MacDonald and Chrismina
MacKay posing with their grandmother
Christina MacDonald of 20 North Dell,
Ness, Lewis, Ross-shire in the late 1950s-
early 1960s.

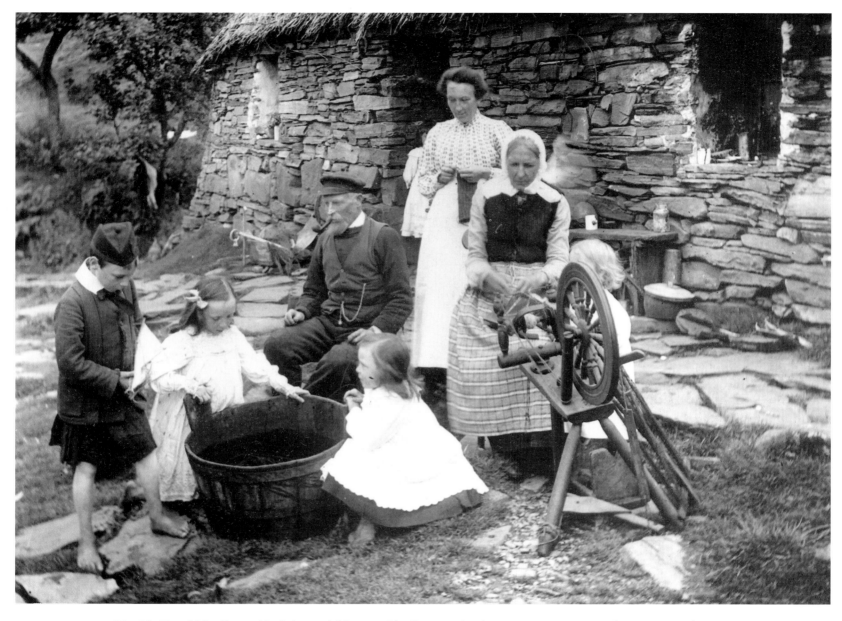

The MacDonald family outside their home at Kinagarry, Morar, Inverness-shire, c1905-10. John MacDonald, known locally as 'John the Fisherman', had married Mary Anne Beaton in 1898. Four of their children are Charlie, Kate, Annie and Peggy. A fifth child is standing in the cottage doorway, perhaps sulking! Another son, Donald, pictured on page 40, drowned as a boy at Kinagarry. The sleeping arrangements in the two-roomed cottage involved father and sons sleeping in the main room, and mother, grandmother and daughters in the kitchen.
Miss MEM Donaldson

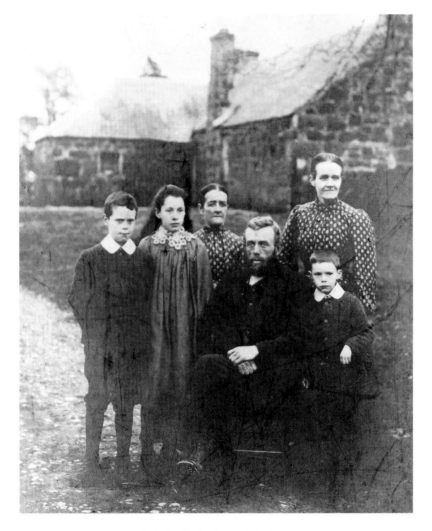

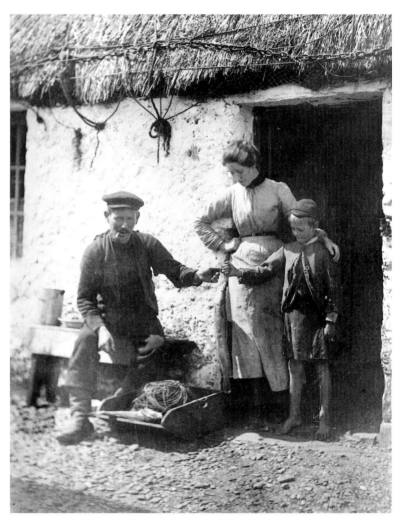

The Keir family in front of their house on the Ancaster Estate at Back o' Drummond, near Callander, Perthshire in 1911. The children are Donald, Catherine and Duncan, who later became a shepherd like his father and grandfather before him. The boys are in traditional knickerbockers, buttoned jackets and Eton collars.

Donald MacDonald showing off his catch to his neighbours at Morar, Inverness-shire c1905–10. The rest of his family can be seen in the photograph on p39.
Miss MEM Donaldson

Sarah and Chrissie MacGillivray of Burg on Mull, Argyllshire, photographed with their parents in 1904. They are also shown in the photograph on p22 with the rest of the family. The pig, the sheep and the dog obviously regard themselves as part of the family.
Miss Maudie Cheape

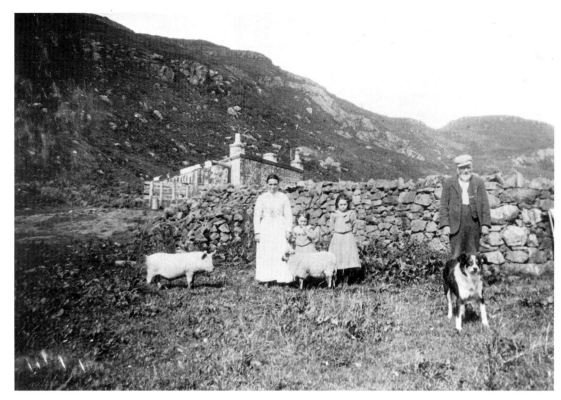

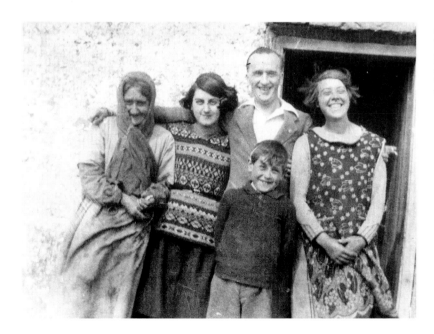

Aunt Reubena Irvine, Mollie MacPherson and John and Bella Irvine with their son John junior, of Fair Isle, Shetland in 1931. Mollie is wearing a beautiful Fair Isle jumper.

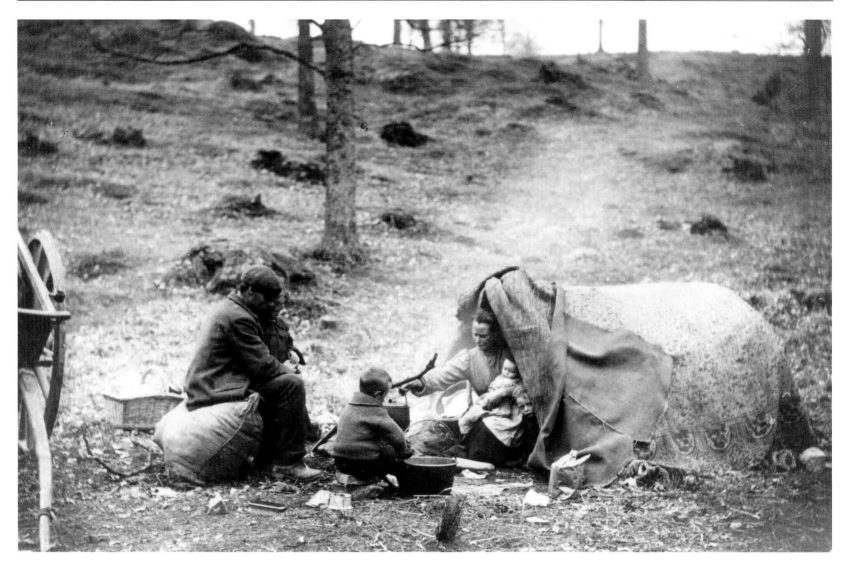

A travelling family preparing a meal
at their camp near Callander,
Perthshire in the early 1900s. The
cover of the bender tent appears to be
a recycled carpet.
J Inglis Kerr

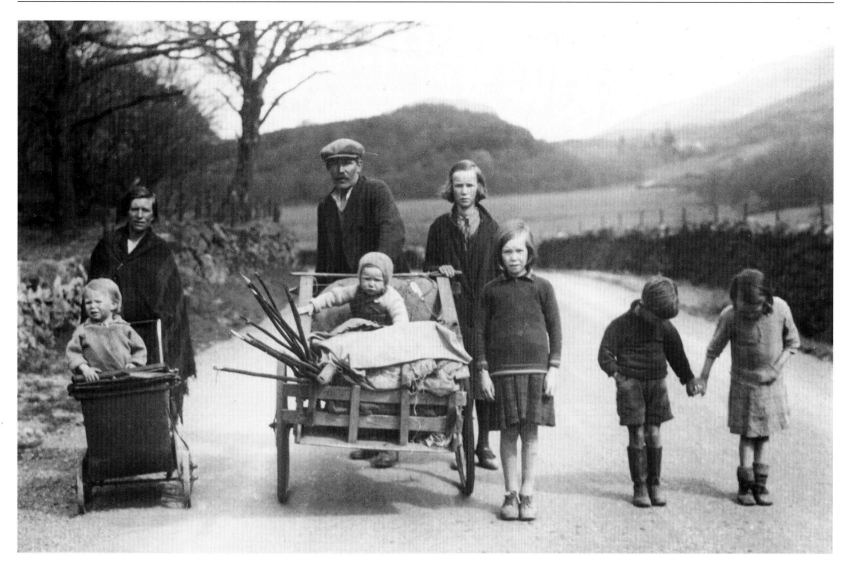

A pearl-fisher with his family on their way from one camp to another, c1930s. The curved sticks and roofing for their bender tent home can be seen in the hand cart. Collecting the pearls contained in some freshwater mussels provided employment for some families for centuries. Today, however, only a few individuals continue the time-consuming search for the elusive pearls.
Hamish Muir

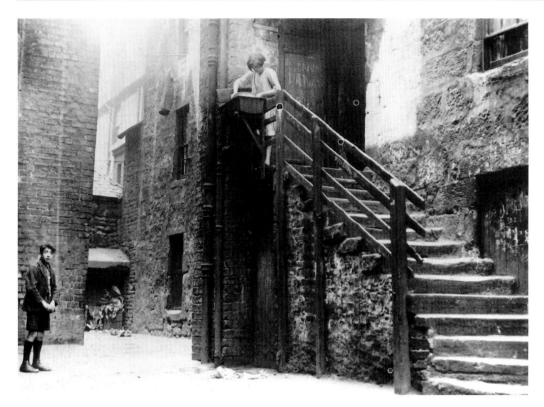

Doing the washing-up on an ingenious platform fixed to the head of the stair at 50 Crown Street in Glasgow's Gorbals, in the 1930s. The Gorbals has since been demolished and partially rebuilt.

Reading a comic or children's magazine in his one-roomed, or single-end, home in Musselburgh's North High Street in August 1939.

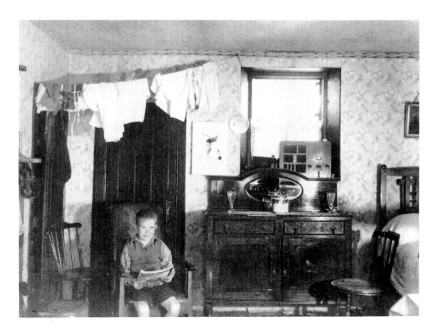

The eviction of a family from Lochmaddy, North Uist, Inverness-shire in 1895. The house had been deliberately demolished to force them to leave. The main Highland and Island Clearances, or mass evictions, took place in the first half of the nineteenth century before photography was developed enough to record them. This is one of a very small number of photographs showing an eviction, although there are numerous written accounts.

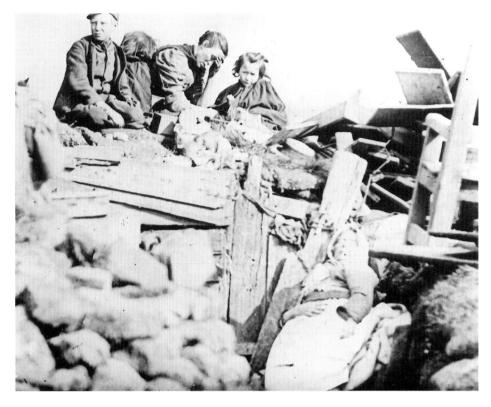

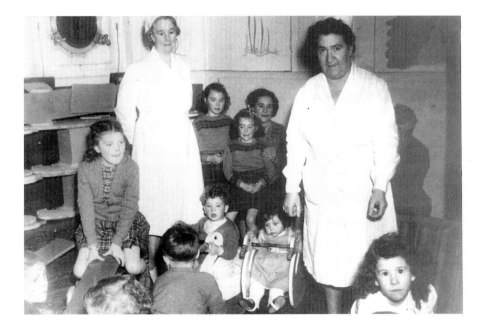

The nursery aboard the emigrant ship *Empire Brent* which left Glasgow's George IV dock in 1949 bound for Australia. Miss McLeod, on the right, was in charge. During the Second World War she had been aboard the *Athenia*, torpedoed while carrying child evacuees to safety in the United States.
Bernard Balkind

Another photograph taken to send to a father serving during the First World War. This is baby Elizabeth Forbes of Fountainbridge, Edinburgh, with a fabulous stuffed toy, photographed in 1917 with her mother, brother and sister. Their father was serving in Egypt at the time.

E W Parker, Edinburgh

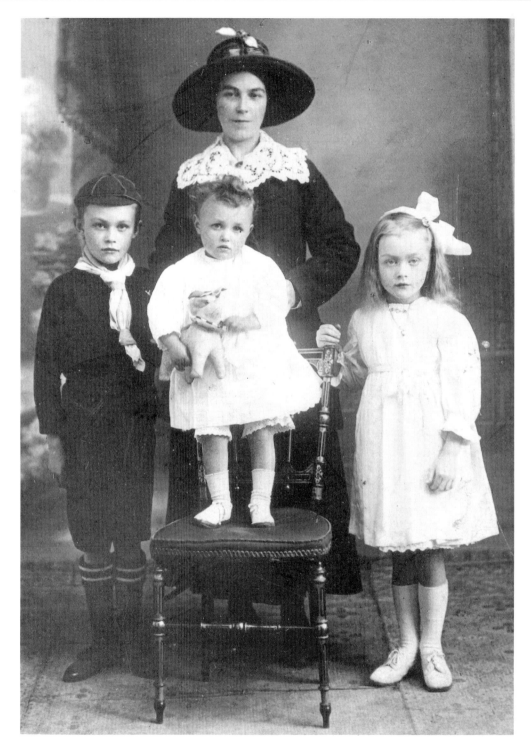

'Flora MacDonald's Lament', played aboard the Canadian Pacific liner *Marloch* on which 300 natives of South Uist left Lochboisdale bound for Canada on 31 March 1924. For many centuries Scotland has sent large numbers of its population overseas. During the Clearances and the Depression the traditional destination was Canada or the United States. After the Second World War many took up the assisted passage scheme and emigrated to Australia on ships such as the *Empire Brent*.
©*Hulton Deutsch Collection*

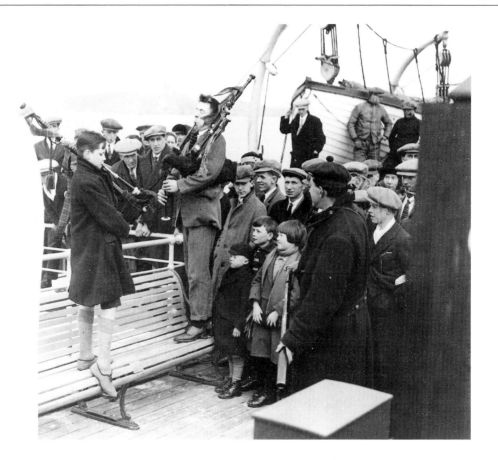

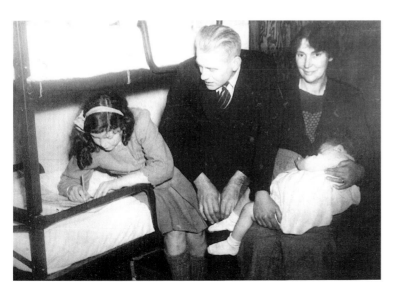

Wendy Turner, writing her diary perhaps. She is with her parents and one of her eight brothers and sisters in their cabin aboard the *Empire Brent*, on their way to a new life in Australia in 1949.
Bernard Balkind

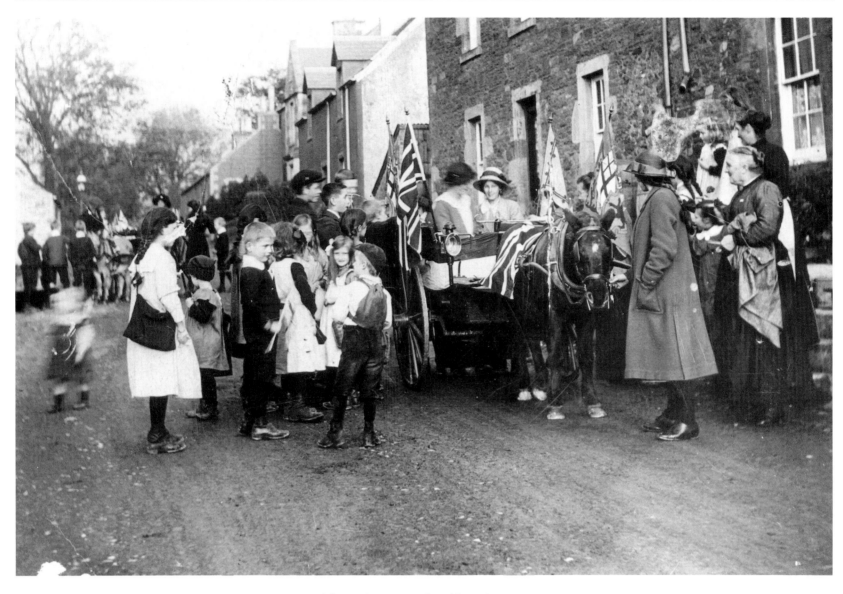

The excitement produced by a First World War recruiting drive in the Main Street, Lilliesleaf, Roxburghshire. The children are obviously unaware of the serious implications the war would have for their families.

Young evacuees from Edinburgh,
with pet rabbits to help cheer them
up, at Middleton House Evacuation
Centre near Gorebridge, Midlothian
in 1940. The teacher is Miss Isabella
M Thomson.
The Scotsman & Evening Dispatch

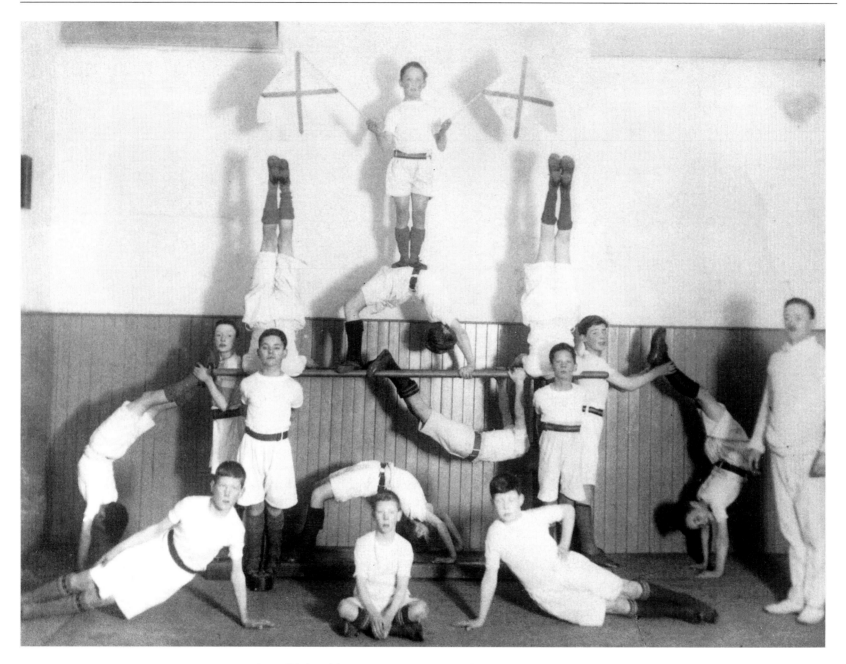

How long did this elaborate gym display at Viewpark School, Edinburgh take to set up in 1904? And for how long did the boy in the centre have to tighten his stomach muscles to bear the weight of the flag-bearer?

Dr Charles W Graham

EDUCATION AND RELIGION

In *The First Book of Discipline* John Knox had called for a school in every parish and an education system open to all Scottish children, irrespective of wealth or social status. Although his vision never became a social reality it expressed national aspirations: long before the Board Schools Act of 1872 made attendance compulsory, Scotland was acknowledged to have a higher standard of literacy than most other European countries.

The dominie of an early parish school was frequently a 'stickit minister', a divinity student who had not been called to a pulpit. Before the Act, Church control of education and its practitioners was thought wholly right and proper: learning was the route to worldly success, but literacy was also necessary to comprehend the Bible and Shorter Catechism. An educated, Godfearing populace was less likely to rebel.

The system set up in 1872 included Inspectors and School Attendance Officers who struggled with problems that had been accumulating over many years. Rural schools served large catchment areas, and pupils had to travel on foot. Transport provision was made obligatory in 1945, but two miles for children under eight (three for those above) was still considered a reasonable walking distance. What might be a pleasant summer stroll could become impossible in winter. Even today, with modern roads and vehicles, some degree of absenteeism is unavoidable.

Highland pupils suffered two other disadvantages. Their home tongue might be Gaelic, but all instruction was in English. Their numbers might be too few to justify the expense of a purpose-built school, and frequently they were taught in a make-shift schoolroom by a last-year student. This led to amalgamation; older pupils began to be boarded near their secondary school.

> When I was young in Glenapp I started in the wee Glen school. That was the teacher's sitting room, Mrs Ross's house. ... But after a while all these wee house-schools in Glenapp and Auchenflower were closed down and we came here to school in Ballantrae. [1]

The informality of these house-schools transcended the class-barriers. Veronica Maclean (Lady Maclean) recalls being instructed in the 1920s by a pupil-teacher who lodged with Archie MacFarlane, her father's gamekeeper, near the shooting lodge at Stronelairg.

> There were nine of us, four MacFarlanes, me and two pairs of shepherds' children from further down the glen who walked four miles to and from the the schoolroom every

day except when they 'managed' a lift with the mail van. Our ages ranged from six to twelve and I think sometimes a MacFarlane baby would be allowed in, as long as it was quiet, to scribble contentedly with crayons in a corner. [2]

In the urban areas there were different problems. The Argyll Commission, whose findings prompted the 1872 Act, had uncovered a huge variety of schools beyond those officially run by the parish or burgh. Each religious denomination had set up its own and there were hundreds of private 'adventure' schools. Except in Glasgow and Edinburgh these were on a very small scale and only a few were socially exclusive, with the result that they took in a surprisingly large percentage of the school population. Their fees were in line with those of the parish schools but they were under no supervision whatsoever. These overlapping arrangements were still vastly insufficient for Scotland's overcrowded cities. It was estimated that in the country as a whole about one-fifth of the half-million school-age children received no education at all.

The majority of children were gradually brought into the system and regular inspections ensured that some standardisation was imposed on teaching methods and content. Earnest endeavour and frequent testing became the norm. Photographs of typical classrooms between 1875 and 1935 show little variation apart from the style of clothing: we see children frozen into rows of desks, with several classes often being taught in the same room. Until the provision of free stationery, spelling and arithmetic were usually practised on slates.

Oh, that slate pencil screeved when you wrote with it and made your teeth grit. [3]

Spit and a rub from a jersey sleeve was the frequent mode of erasure for boys, while girls seem to have preferred a moist rag kept in a box. Reinforcement was through chanting and endless repetition. Yet the drudgery is often recalled with approval.

D'you remember Vere Foster copy books? ... with their proverbs in joined-up writing along the top of each page and maybe five blank lines to make better and better copies? I loved my Vere Fosters. [4]

Compulsory schooling from six to thirteen was intended to produce a workforce well-grounded in the three Rs. At first there was no financial provision for secondary schools. The old parish schools never drew a hard distinction between elementary and secondary education, and sent on many of their pupils to university; the 'lad o pairts' who rose above his unpromising background was not a total myth. (It was never a lass until much later.) Up to the 1890s boys could leave school for university at what would now seem an abnormally early age and Scottish students were drawn from a much wider swathe of society than those in England. At the same time, other factors militated strongly against children from poorer families reaching their full potential.

Subjects were charged individually, which meant that parents could not afford the full curriculum without considerable sacrifice. Elementary education was not completely free until 1891, and there was no statutory financial assistance with books, equipment or travel until 1908. The fees charged by some secondary state schools were not entirely abolished until after World War Two.

The greatest obstacle could be the family's need for another breadwinner.

> I'd no option but to leave school. ...Three different councillors from Pittenweem came to my mother to see if I couldn't get to stay on. but she said she needed me to be working. ...I just went straight to the fishing at fourteen. [5]

The dilemma became worse as the school-leaving age was successively raised to fourteen in 1901, fifteen after World War Two, and to its present level of sixteen in 1972. Nevertheless, what the law decreed never applied to everyone. Before school attendance was compulsory the absenteeism of country children during harvest was an accepted fact, in the same way as children continued to go into full-time work in industrial areas at eight or nine, despite the Factory Acts. Even after 1872 many exceptions for early leaving were admitted. The most notorious concerned the twelve to fourteen-year-old girl shifters in the jute mills of Dundee. In 1900 five thousand of them attended school only on half-days or alternate days, or in the evening after a twelve-hour work shift. These 'half-timers' did not disappear completely until 1936. As the majority of children began to stay on longer at school Acts were passed to cover secondary education. Late nineteenth-century attempts at rationalisation produced some dubious side-effects: in Edinburgh several trust funds were appropriated and the residential charity hospitals transformed into fee-paying day-schools for the middle classes. Similar effects followed in designated Higher Class Schools in the burghs. Attendance at these schools became fissured along the lines of social class, as it still is, despite the drive towards comprehensive education since the 1960s. As Professor Smout has demonstrated in *A Century of the Scottish People*, Scottish urban education was never truly democratic.

Apart from Glasgow, Edinburgh, and Aberdeen, burgh schools had always taught girls alongside boys. It was hardly co-education in the modern sense, since there were separate playgrounds for girls and boys, and classroom seating and even some classes were segregated. Yet even this degree of mixing, paradoxically, held back the extension of higher education to women. Girls attended senior classes taught by male graduates long before they themselves were admitted to University courses, and the need for women teachers at academic level took a long time to surface. At first their presence was confined to girls' schools that had no dealings with the unprivileged majority. These girls' schools were also unique in being the only place where teachers did not enforce discipline with the tawse or 'belt', a leather strap cut

into fringes — sometimes knotted — at its working end. The use of the tawse is now banned.

The 1872 Act had guaranteed religious instruction according to 'use and wont' in the new state schools, but this was only instruction acceptable to the various forms of Presbyterian belief. Most Episcopalian and Roman Catholic schools preferred to safeguard their doctrine by remaining independent and supplementing the government grant out of their own funds. Under these conditions they found it difficult to maintain equal standards of teaching and staffing. In 1918 they were given the chance to transfer to the new Education Authorities with their denominational status guaranteed. This imaginative offer, which was accepted by most of the schools, solved the educational problem for religious minorities, but provoked cries of 'Rome on the Rates' from Presbyterian fundamentalists. Today, sectarianism is happily less prevalent even in Glasgow, which has a long history of conflict in this area. It would be surprising if we did not find adult disputes reflected in the tribalism of childhood. 'Proddies' and 'Papes' — otherwise a 'Billy' or a 'Dan' — traded insults and fisticuffs when they met in the streets; but even in the early years of this century a rousing spectacle could always tempt a child into tolerance.

> I'm a Roman Catholic but I used to like to see the Orange Walk when I was young. ... the drums and whistles, y'know? I remember once making my father's hair stand on end by coming in saying how I'd watched it and *waved*. [6]

[1] Blair, *Croft and Creel*, p104.
[2] *A Scottish Childhood*, p86.
[3] Blair, *Croft and Creel*, p106.
[4] Blair, *Tea at Miss Cranston's,* p164.
[5] Blair, *Croft and Creel*, p109.
[6] Blair, *More Tea at Miss Cranston's,* p222.

Pupils, teacher and nurse of Duncan Street Special School, Edinburgh, in about 1914. The boys are wearing either buttoned jackets or 'ganseys', practical navy-blue woollen jerseys based on the fisherman's sweater. The younger girls wear the usual pinafore dress while the older have graduated to a skirt and blouse.

The covered cart may have been used for outings and to help the pupils with more serious disabilities get to and from school. The 1906 Act allowed School Boards to extend provision for disabled children beyond those with sight and hearing difficulties.

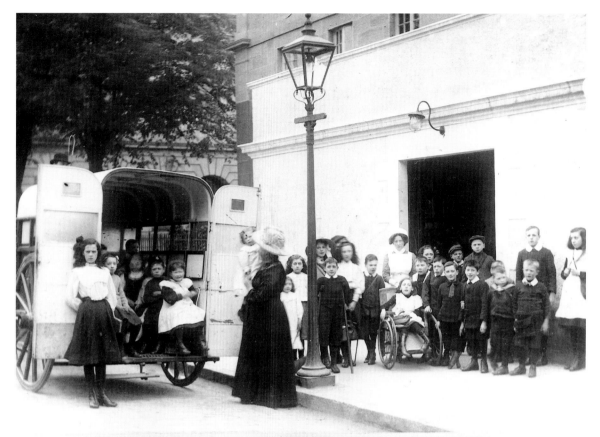

Charles and George Graham on their way home from their preparatory school Viewpark, in Edinburgh, in 1904. The English-style caps (as worn by Richmal Crompton's William) show that they attend a fee-paying school; the leather bookstrap with a handle was a common alternative to a satchel.
Collection of Dr Charles W Graham

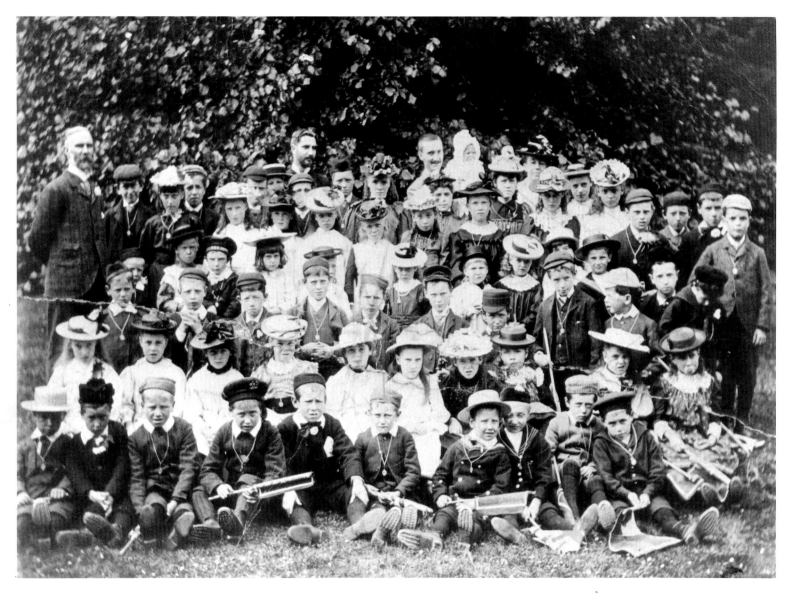

Pupils and staff dressed in their best clothes at Lamington School, Lanarkshire in 1910, for the coronation of George V. Some children hold patriotic flags and most seem to be wearing commemorative medals round their necks. It was usual for schoolchildren to be presented with some small gift on Coronation Day.

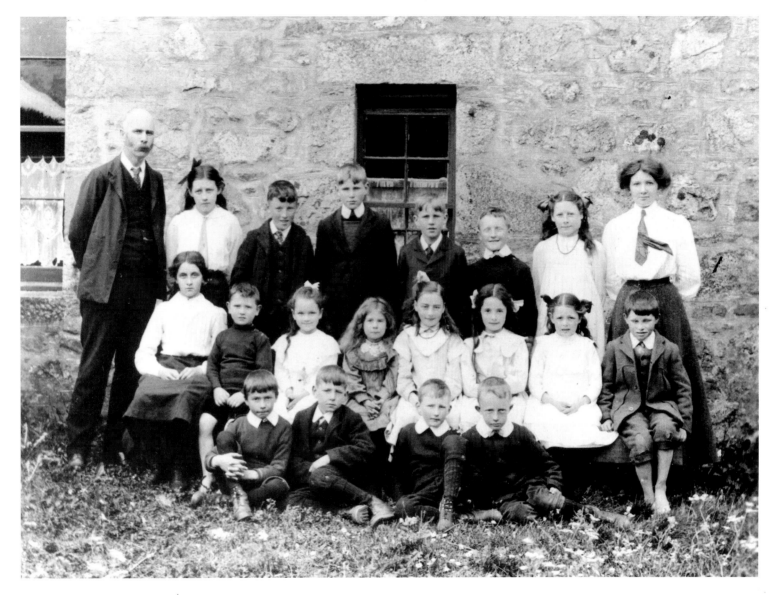

Teachers Sam Cruickshank and Miss Cochrane with their pupils at Tarfside School, Glenesk, Angus, about 1913. The pupils are, back row: Cathie Shepherd, Archie Stewart, John Littlejohn, Henry Littlejohn, Alexander (Sandy) Stewart and Katie Jolly; middle row: Margaret Menzies, Duncan Michie, Margaret (Greta) Fairweather Michie, Ruby Lowden, Davina Skene, Lily Leighton, Ella Jolly and Willie Dunbar; front: Jimmie Lowden, Robert Littlejohn, Charles Duncan and James Stewart. Willie Dunbar looks very self-conscious, perhaps because of the torn knees of his knickerbockers. He is barefoot, but others are wearing 'tackety' (hobnailed) boots.

Margaret Fairweather Michie (1905-1985) went on to become a teacher in Brechin, Monifieth and then Tarfside herself, and founded the Glenesk Folk Museum in 1955.

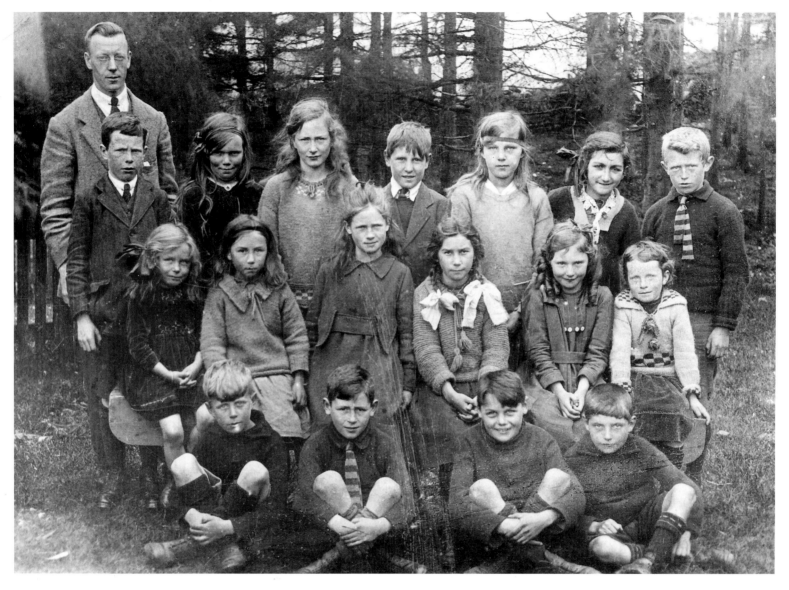

A later photograph of Tarfside School, taken about 1922. The hairbands worn by several of the girls were the height of fashion at this period, although most of their hairstyles look as though they could have done with a comb before the photograph was taken. Had the mother of the little girl with the ringlets been told that the photographer was coming, or was her hair curled regularly? Ringlets would be made with heated tongs or by twisting rags in the hair, to be slept in overnight.

Class IIIA at Buckhaven High, Fife in 1937-8. They are, back row: Norman Smart, Tom Rattray, Lesley Webster, Jack Venters, John Keddie, James Fallan, David Prentice and Alec Henderson; second row: David Dunsire, George Boulton, Bob Thomson, Sandy Mitchell, Andrew Douglas, Terry Burns and Bob Dow; third row: Marion Cameron, Bessie Newbigging, Milly Marshall, Margaret Young, Eira Bauchop, Jean MacPhail, Dorothy Duthie and Loyse Mitchell; front row: Maisie Cargill, Ella Peebles, Mae Aitken, Hannah Watson, Mary Pride, Isa Herd, and Helen Todd.

The boys in this picture are still in shorts (you can just see Norman Smart's legs), although they must be fourteen or fifteen. The girls are wearing the pleated serge gym slips universal in British schools (with uniform regulations) in the first half of the twentieth century. Four of them are also wearing badges. The badge and Day School Certificate awarded to Eira Bauchop are now in the National Museums of Scotland collections.

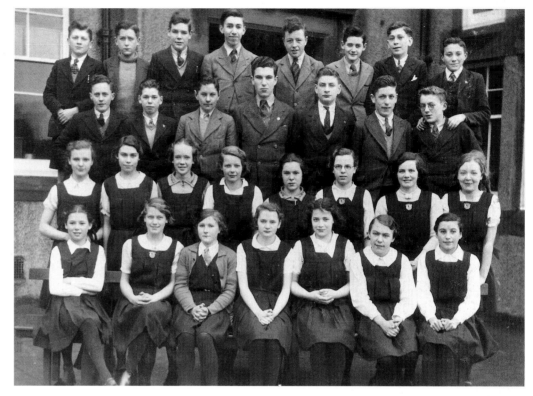

Tarfside school children again, this time in about 1938. Sadly, Sheila Mitchell, the little girl second from the right, accidentally drowned in the river North Esk shortly after this photograph was taken. It is noticeable that, compared to the previous Tarfside group, the children show a wide variety of dress.

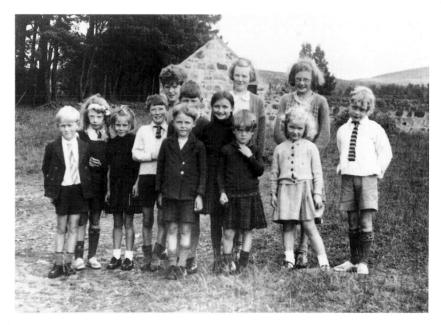

Clay modelling in the Infants Department of Drummond Street School about 1914. Plasticine dates back to the end of the nineteenth century, but would have been much more expensive, though less messy, than clay. Though rather stark by the standards of today's primary schools, this classroom scene nevertheless belies the image of young children being made to work exclusively on their three Rs. A classroom such as this can still be experienced today at Scotland Street School Museum in Glasgow.

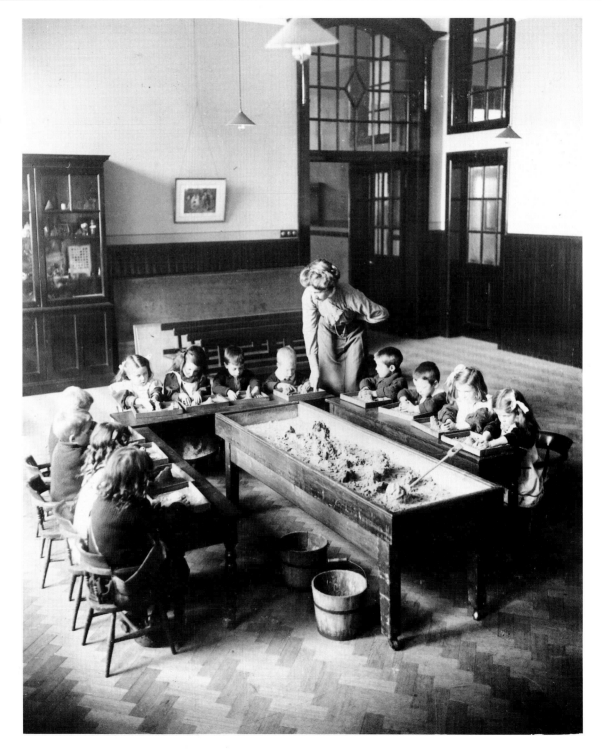

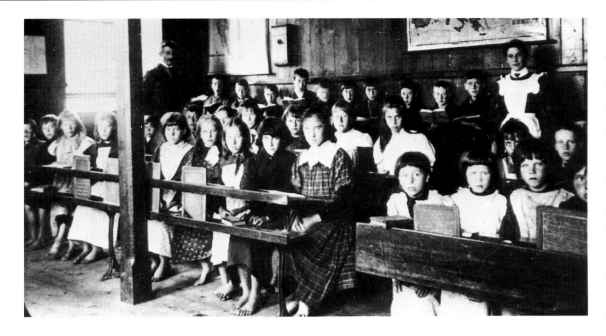

Intent-looking pupils in a classroom of Glencoe village school, Argyll, about 1900. The overcrowded look may be due to pupils being crowded together for the photograph, though many village schools held more than one class in each room – often there was only one classroom.

Bare feet were common for country children in the summer as they saved on footwear and were also no doubt far more comfortable. Note also the slots in the desks for the storage of slates – these large slates may have come from the nearby Ballachulish quarries, though most school slates came from Welsh slate quarries where they were cut, ground, polished and framed.

A singing class, perhaps, in Miss Hope's Primary I class at Biggar Primary School, in the late 1950s. Posters and stained glass-effect illustrations decorate the walls and windows. Boys and girls are mixed in together where in earlier times they were segregated by choice and custom, even down to separate playgrounds and separate doors. The desks look very up-to-date with tubular frames incorporating the seats – and no inkwells.

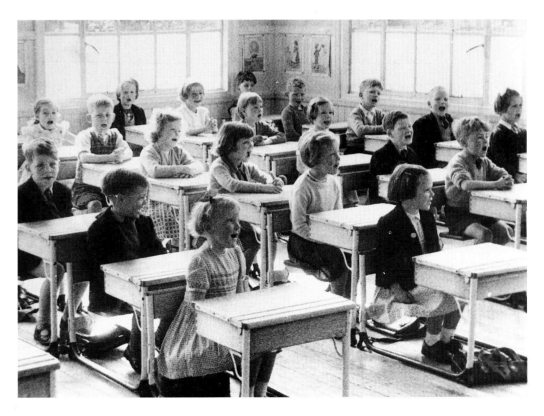

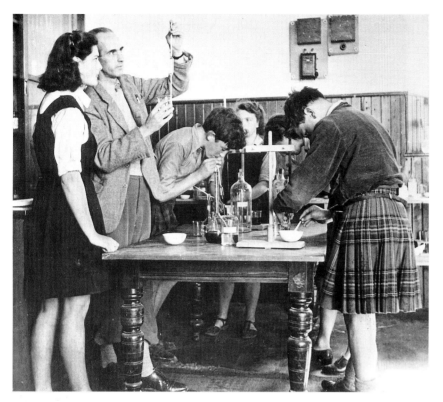

A lesson in volumetric analysis at Cally House School, Kirkcudbrightshire in 1942. The Science Master is Kenneth Macrae. Although science subjects have been offered to girls for all of this century, gender conditioning and social expectations still ensure that far fewer girls than boys study sciences in co-educational schools, thereby limiting their career choices.

There seems to be an alarming lack of safety equipment by today's standards.

Pictorial Press

The language laboratory at Craigmount School, Edinburgh during the 1970s. Note the cartoon illustrations being used to illustrate this French lesson. The modern emphasis on fluency in the spoken language has replaced the strictly grammatical approach through verb tables and prose composition, which could produce adults who were excellent readers of French but unable to ask for a ticket on the Metro.

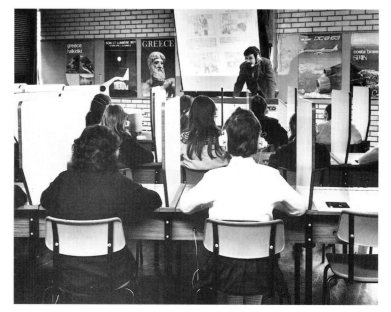

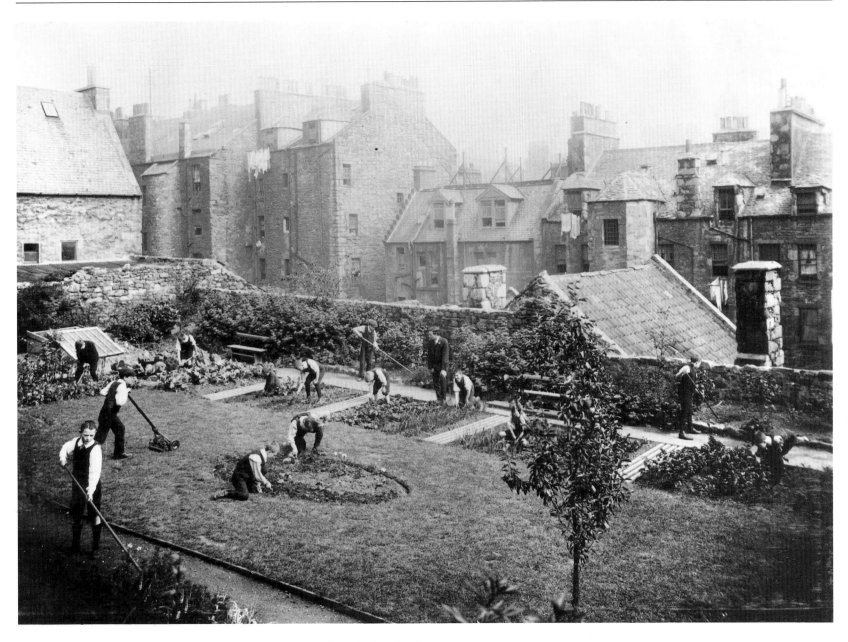

A gardening class in progress at
Castlehill School, Edinburgh, about
1914. A variety of flowers and
vegetables are being tended.

A fire drill in progress at Flora Stevenson's School, Edinburgh, about 1914. In such a large city school, the drill must have been both an exciting and an important event, as well as a welcome break from lessons. It is possible that this drill was connected with precautions against the Zeppelin raids on Edinburgh in the First World War.

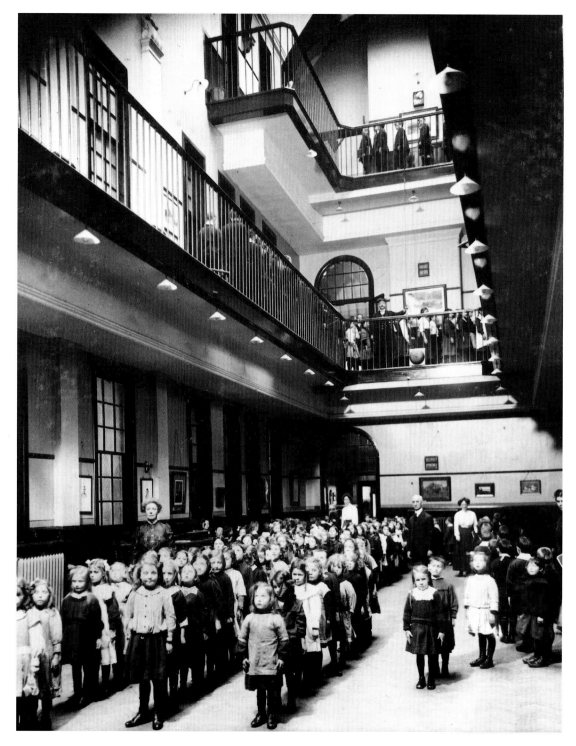

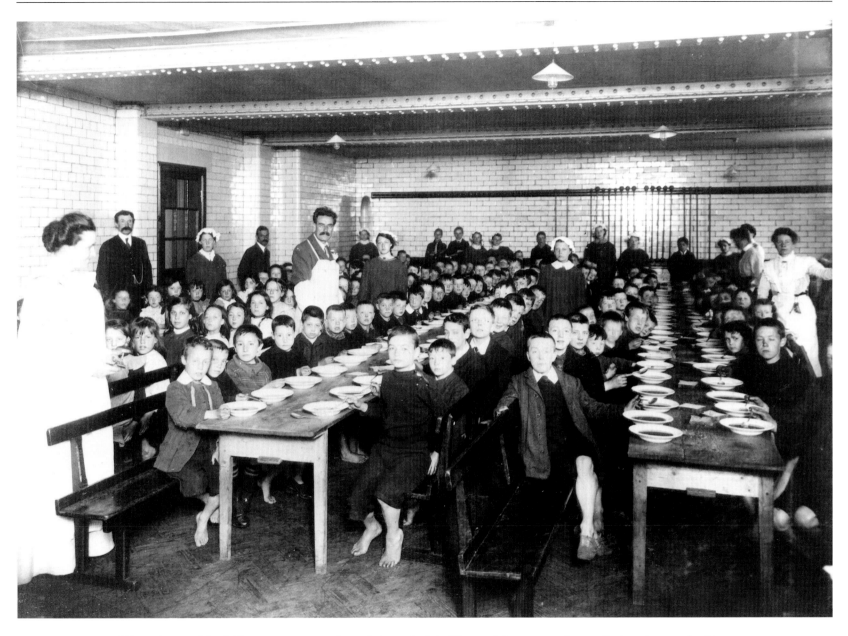

Dinner hour at North Canongate School, Edinburgh in about 1914. Most of the teachers and some older girl pupils seem to be doing dinner duty. Note the large bell held by the dinner lady on the left. The 1908 Act allowed schools to provide meals and other services for their pupils regardless of the actual cost. These children's faces show clearly that this was a vital supplement for low-income families, even if the food was limited and plain. In 1939 those children who did not get their school dinners free still paid only 3d for them.

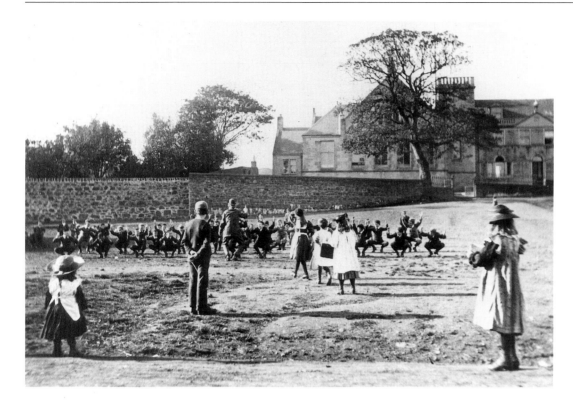

Campbeltown Grammar School boys being drilled on Stewart's Green around 1900. The delighted look on some of their faces suggests that their instructor looks as funny from the front as he does from behind.

The emphasis on physical education was of military derivation. It was not until 1924 that PE instructors had to have a three-year training qualification and at this period those giving instruction were usually ex-servicemen. Local School Board minutes record: 'Sgt. Instructor Robert Smith appointed to give Drill Instruction 2 days a week,... ½ hour daily,... at a salary of £5 per annum'.

The report of the Royal Commission on Physical Training in Scotland, appointed in 1902, concluded that it was not Military Drill which was required but physiological exercises.
Charles & Dennis MacGrory

Bonnets and boaters seem firmly anchored during this lively grand chain, possibly at Argyll Street School, Campbeltown, Argyll, around 1900.
Charles & Dennis MacGrory

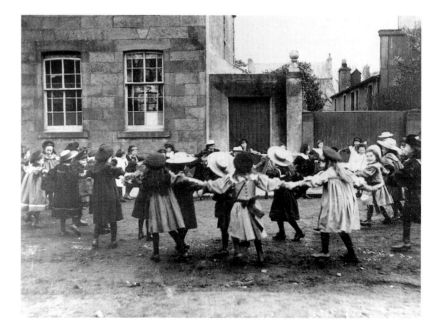

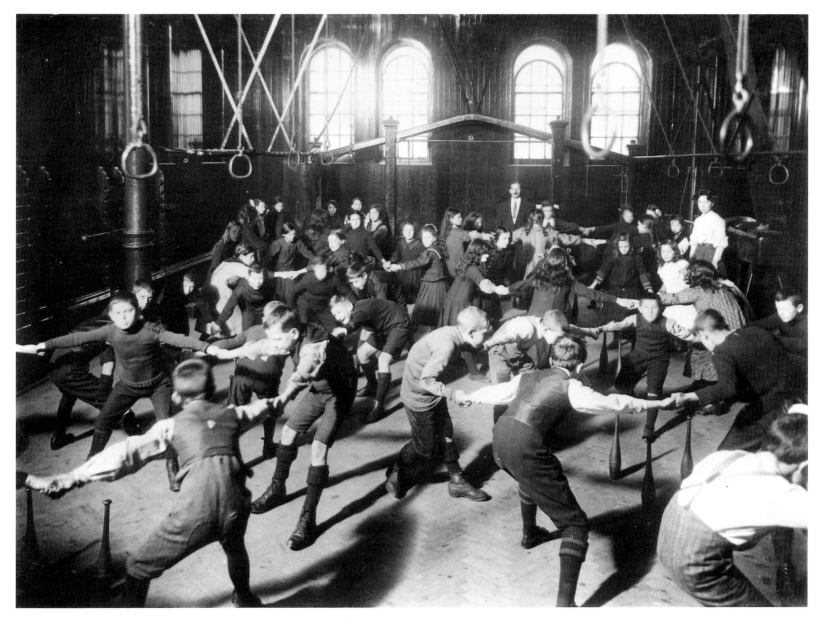

A sort of circular tug-o'-war during a physical education class in the well-equipped gymnasium of Sciennes School, Edinburgh, in about 1914. Both boys and girls are wearing their ordinary school clothes – the Education (Scotland) Act of 1946 allowed schools to provide pupils with suitable clothing for physical exercise, but until then many children would not have had special outfits for PE.

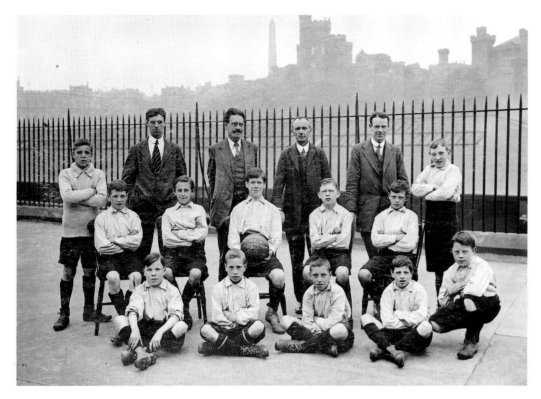

Edinburgh's North Canongate School's champion football team, in the 1913-14 school year.

Learning to swim with waterwings (or suspended from the ceiling) in the pool at Sciennes School, Edinburgh, about 1914.

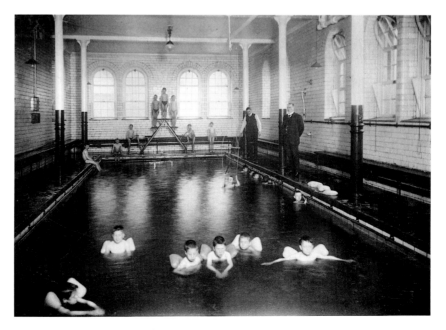

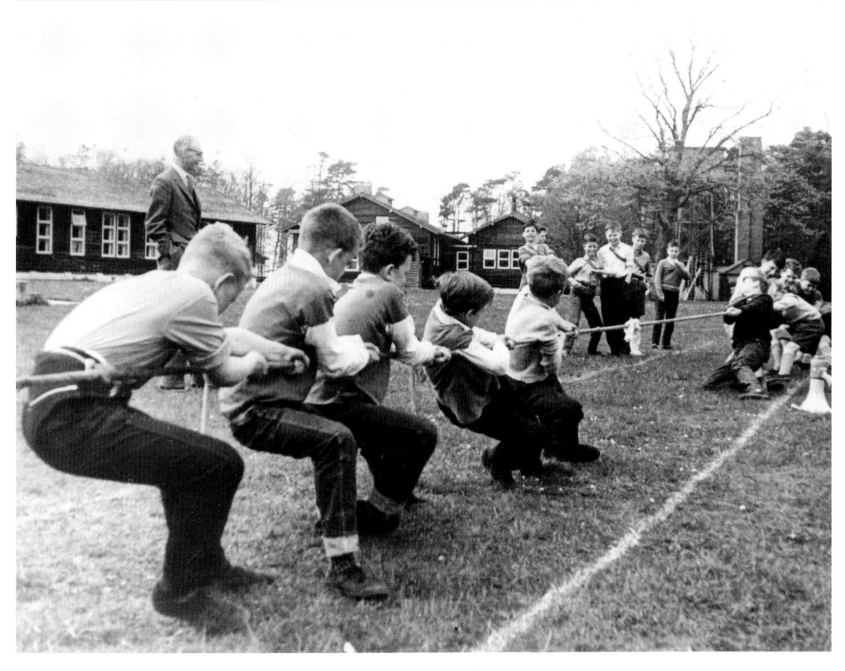

A tug-o'-war at Glen Gonnar school camp, Abington, Lanarkshire, in the 1950s. Town children would spend one to four weeks at the camp, combining formal school work with sports, exploring the district, and visiting places of interest such as Edinburgh or the Border country.

Taking a bearing at the School for Pioneers at Glenmore, Inverness-shire in 1951. Outdoor education has become an increasingly important part of the school curriculum, for both boys and girls, as the twentieth century has progressed. Many will remember the adventure of getting their Duke of Edinburgh Award.
James Gray

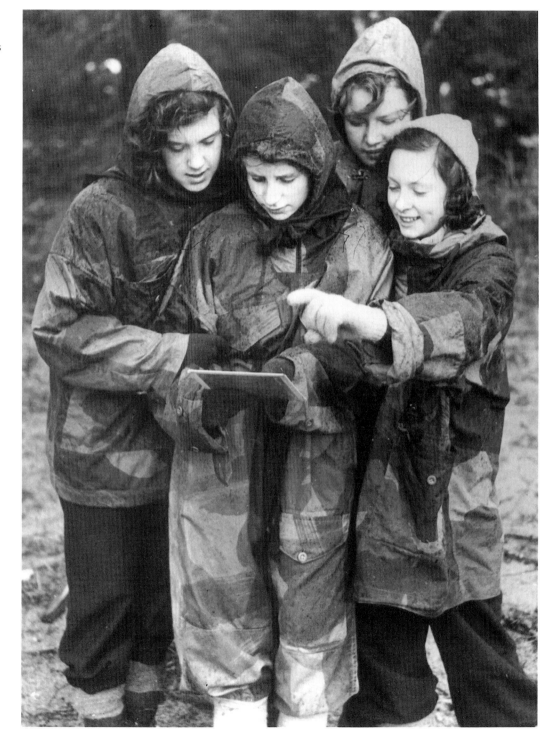

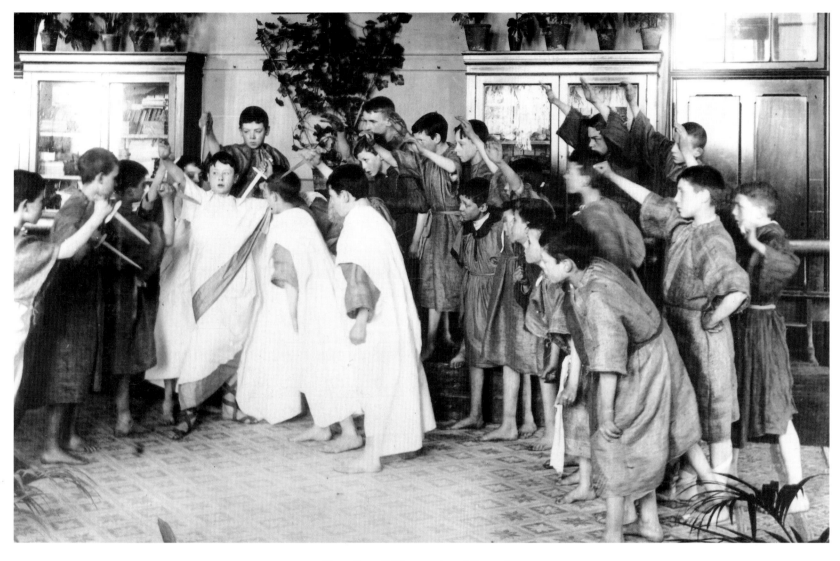

'Et tu Brute!' The murder of Caesar in
full swing during a performance of
Shakespeare's *Julius Caesar* at Castlehill
School, Edinburgh, about 1914.

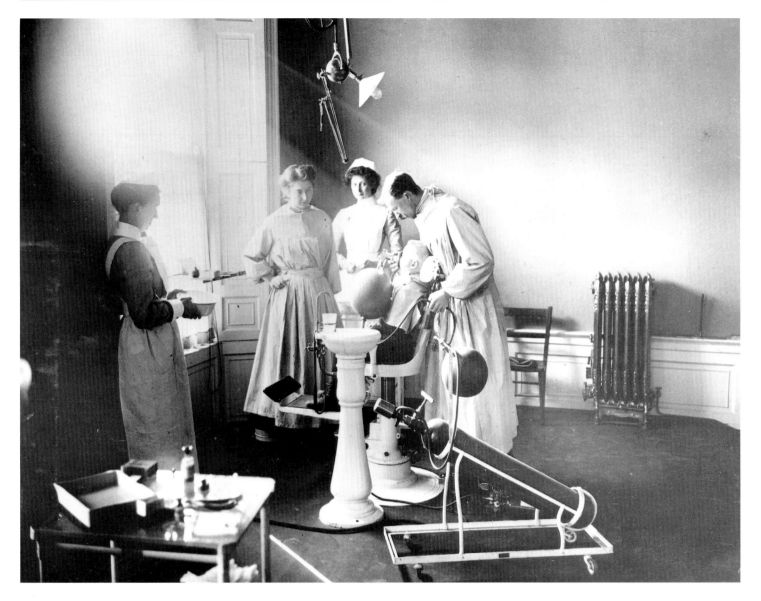

A terrifying experience for a child –
being anaesthetised prior to having a
tooth extracted at Lauriston Place
clinic, Edinburgh, in about 1914. The
woman dentist is holding the claw–
like instrument with which she may
be about to remove the tooth.

SICKNESS AND HEALTH

Today's children are tomorrow's adults, but this obvious fact had little effect on national policy until the outbreak of World War Two. Before then, most health legislation was an attempt to eradicate infectious diseases. With the exception of compulsory vaccination for smallpox, improvements in health care were not specifically directed at children, although they were more vulnerable than adults to the scourges of diphtheria, scarlet fever, measles, and whooping cough. By 1939, with the discovery of vitamins, the link between nutrition and health was better understood. The wartime diet of juveniles and pregnant women was given top priority; all children were provided with milk at break-time and school dinners. For everyone meat was rationed to about a pound a week, butter wavered between two and four ounces, and eggs were two or fewer. The nation was convinced that it would starve; yet it produced the healthiest generation in its history.

Long before 1939 great advances in hygiene and medical science had drastically reduced the death rate, especially among the young. In 1861 children under ten accounted for 54% of all deaths in Glasgow and one in five of all babies born in the city's tenements died in their first year. Nevertheless, child and infant mortality remained high after the overall Scottish death rate began to fall in the last quarter of the nineteenth century.

> We had a wee one ... who died. She had meningitis... Grace was two and a half when she died... I was told to go away for the funeral... I resented being sent away... I went and stood in Arthur's Close. Stood with the children there. Because I wanted to see what they were going to do with Grace. ... The coffin was just sitting in one of the cabs. ...I remember sitting waiting up with Grace all through the night ... and they'd sent me out the next day ... for a message up to the Co-operative or something. Sent me out, and when I came back, Grace had died. I thought, 'If I had been there, I wouldn't have let her go.' It shows you. You don't think that children are much affected by that. ... I was depressed, yes. [1]

By the 1850s many inner city tenements had become over-crowded rookeries with no access to the primary decencies of life. There was self-interest as well as social conscience behind the campaign for pure water, because rich and poor were equally susceptible to the epidemics that ravaged nineteenth-century society. Glasgow's supply from Loch Katrine was acquired as early as 1859. Yet its sewage disposal — as generally in Scotland — had to wait another twenty years for a satisfactory overhaul.

Glasgow's housing remained among the worst in Europe until well into the twentieth century. Similarly, vested interests in small towns and villages fought hard against the expense of water improvement, Forfar holding out longest until 1877. Local Health Officers had been appointed from the 1860s onwards, and during the rest of the century a series of Food and Public Health Acts were passed to ensure hygiene for the whole community.

Through these measures, most of the virulent diseases had been eliminated or severely curbed by the time of the First World War. Lesser infections were still prevalent in crowded environments. The 1908 Education Act gave schools the right to institute medical inspections and deal with the results.

> All three of us boys had impetigo. ... They had big sulphur baths and they used to soak us in there for an hour at a time. ... We had lots of lice. ... And after you got your head shaved, they used to scrub it with kerosene. [2]

Children's heads were also shaved for ringworm and scabies; at a special school in Edinburgh, boys and girls had their bald heads painted with gentian violet and were only distinguishable by their clothes. The treatment seems drastic, but it was successful. Such outbreaks are rare today.

The fever hospitals built by the Victorians originally catered for all age-groups. There was strong resistance to removing young children from their mothers, and the priority was to separate contagious cases from general patients. When special hospitals for children were established a large part of their work was to treat the result of home accidents such as burns and scalds. Their original bed capacity was very small; voluntary nursing associations attempted to make up the shortfall. An extract from one nurse's diary (printed in *The Glasgow Medical Journal* for 1878) reads:

> James M. — New patient, twelve years old — Dropsy, Abscesses, Bedsores. Deserted by father and mother; kept by grandmother, who drinks. Had to borrow a neighbour's key to get in, the woman being in the habit of locking the child in by himself for hours, with nothing to eat but a few bits of stale crusts.

Fifty years later many infectious diseases had become notifiable, and the notorious Fever Van would arrive to snatch children away to hospital. They were kept in quarantine, possibly for several months. Through the use of allocated numbers local papers published details of who was 'improving', who was 'worse', and who was 'seriously ill'. The Sanitary Department sent men round to the patient's home to disinfect it with shovelfuls of rock sulphur burned over the fire. School books and personal possessions had to be destroyed. Hardest of all was that family visits to the bedside were not permitted. Parents and children could only communicate dumbly through a glass window. Sometimes there was rebellion.

I had diphtheria. I was five years of age. And my mother and father couldnae get to see me. It was just through the glass. With a wee white gown on, my head shaved. So my father said, "Right, that's it. She's no gettin' any pity from anybody." Took us oot and the doctor says, "Do you realise what'll happen to you if anything happens to your child in your care. You are held responsible." He says "Aye!" Hurled me about in a pram till I got better. It was aboot a year till I got better. [3]

Children's experiences at Ruchill Hospital made their way into the skipping rhymes of Springburn:

Here comes the nurse with the red-hot poultice
Claps it on and takes no notice.
Oh, says the patient, that's too hot,
Oh, says the nurse, that is not. [4]

Home remedies were applied to less serious complaints; some of them such as the salt-filled sock for a sore throat might be classified as folk-medicine. If children were coughing they were held over the nearest tar-boiler in the street, in the belief that its fumes would clear the chest. Even affluent parents might go straight to the chemist. J J Bell recalled being dosed with steel drops, senna, tincture of arnica, sweet spirits of nitre, flowers of sulphur and camphorated olive oil, as well as the more expensive patent medicines. Some practitioners scaled their fees, but poorer families tried hard to avoid calling in the doctor. Only a minority of births took place in hospital until the 1950s; medical help would be called in, but in emergencies there was usually a neighbour competent to manage a home delivery.

Once the infectious diseases were under control, children's health varied according to environment and diet. 'The wee hard man' of urban myth was a product both of his own childhood and his mother's malnutrition during puberty. Class differences in height and weight began to diminish by the end of the Second World War, although rickets persisted for a long time in the densely populated inner cities. Diet had certainly improved by the later nineteenth century, but the availability of imported cheaper food from the 1870s onwards was a mixed blessing. Where poverty did not entail absolute starvation, the new types of food tended to displace healthier fare, substituting white bread, tea and sugar for the traditional herring, potatoes and oatmeal. The change in diet, together with the notoriously sweet Scots tooth, produced a 20% leap in the incidence of unsound teeth among Glasgow children in the ten years after 1914.

Tuberculosis actually became more widespread in the Highlands at the end of the nineteenth century. Children build up immunity to TB as they grow up, but this immunity decreases at puberty, especially among girls. Improved nutrition, in particular the pasteurisation of milk from the 1920s, and better housing greatly

reduced the death rates from TB during the first half of the twentieth century. Mass X-ray campaigns were also carried out, but were found not to be cost-effective and given up. The discovery of an effective drug treatment finally put an end to the misery experienced by people sent to sanatoria, supposedly to recover, but often to die lonely, away from their families and friends.

It has been calculated that the final height of adults hardly changed at all during the whole of the nineteenth century. The upward leap took place entirely in our own. In 1910 the average thirteen-year-old Glasgow schoolgirl stood about four and a half feet tall and weighed not much over five stone, while her male counterpart was only a fraction taller and half a stone heavier. By the 1950s children of this age had gained four inches in height and fifteen pounds in weight.

When the NHS was set up in 1948, only two of the old health problems remained, tuberculosis, which affected older children and young adults, and choking smog in the cities. A successful drug treatment for TB was discovered in 1955, while smokeless fuel regulations helped clear the urban atmosphere — at least until it was polluted again by vehicle exhaust emissions. When the post-war generation of children began to tower above their parents, rueful jokes were made about free milk and orange-juice.

It remains to be seen whether the health of their own offspring will continue the improvement, or whether the growing addiction to junk food and television will reverse the gains made by their parents and grandparents.

[1] Faley, *Up Oor Close*, p162-3.
[2] Tollcross History Project, *Waters under the Bridge*, p117.
[3] Faley, *Up Oor Close*, p159-60.
[4] Faley, *Up Oor Close*, p160.

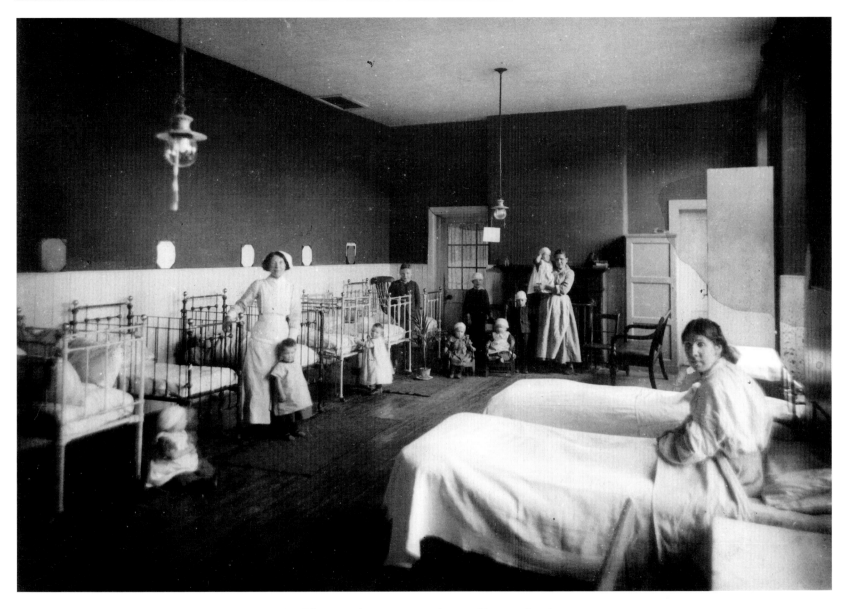

Mother and toddlers' ward at Craiglockhart poorhouse, Edinburgh, between 1904-1914.

Some of the children have had their hair shaved off and heads bandaged to treat lice or the skin disease impetigo. Lice were killed by an overnight carbolic oil soak, next day combing out the nits or eggs, or followed by another overnight vinegar soak. The quickest method, however, was simply to shave the head. Impetigo was treated with a starch poultice followed by painting on a solution of gentian violet.

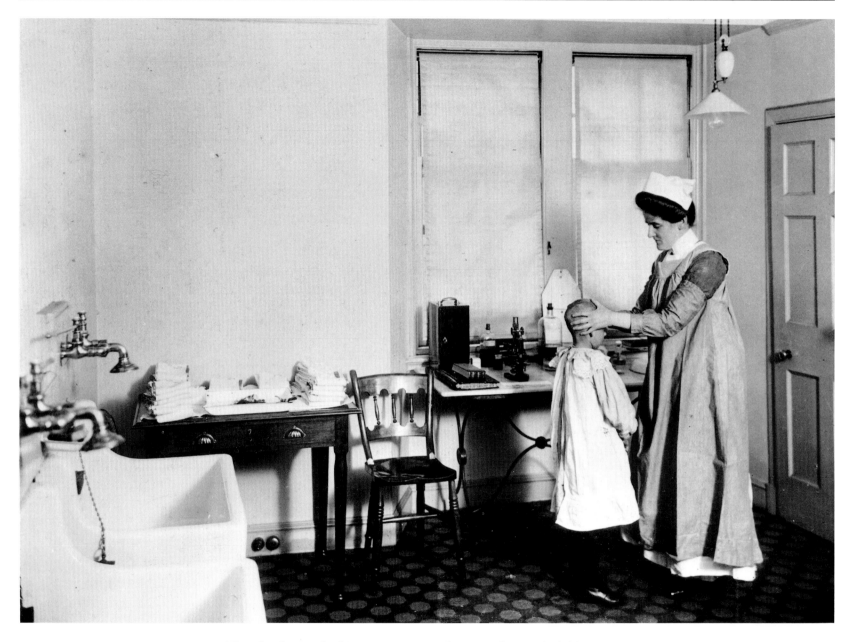

The school nurse checking a young girl's head for lice or ringworm at Lauriston Special School, Edinburgh, about 1914. The skin disease ringworm could be treated by shaving the head before painting it with iodine or applying Whitfields ointment. These early pictures show a striking contrast with conditions today, when dentists and doctors try to make their surgeries less frightening, especially for young patients.

Brother and sisters watch fascinated as this baby gets a smallpox vaccination from local doctor Lachlan Grant in the village of Glencoe, Argyll, about 1900. Dr Grant also practised as the local dentist and optician.

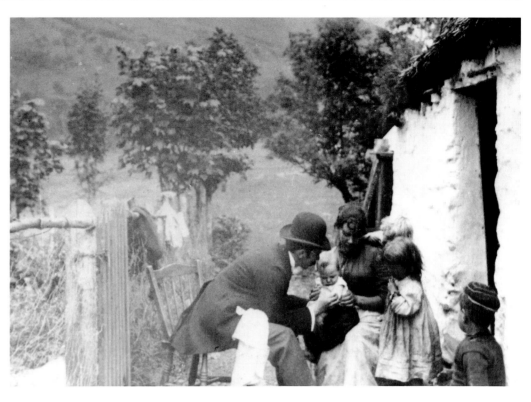

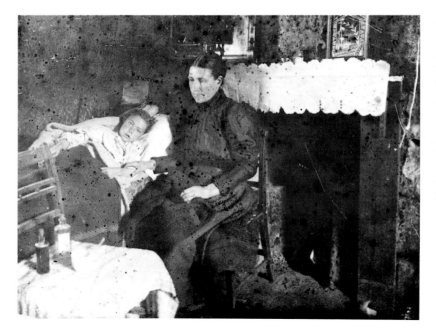

A sick child with her anxious mother, possibly in the village of Glencoe, Argyll, about 1900. Child and infant mortality was a very real threat even for the well off before modern advances in medical care. The chair used to hold the child's medicine bottles may also serve as guard to keep her from falling out of bed in her sleep. The fireplace has a particularly fine lace-style valance made from an old newspaper.

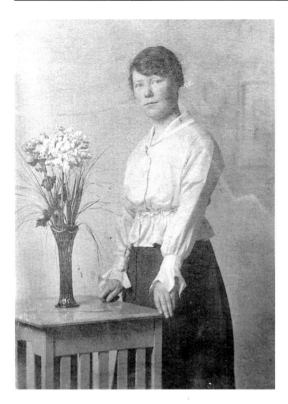

Effie Macleod of Carloway, Lewis, Ross-shire. Photographed in the spring of 1918 shortly before she died of tuberculosis.

Yolande and Alfred Coppola of Edinburgh, obediently posing in extraordinarily elaborate costumes at the photographer's about 1910. Their parents ran an ice-cream shop in Leith Street. With the advent of motor-vehicles of all types at the beginning of the twentieth century, the street became a much more dangerous place for children. Alfred was killed by a tram in Leith Walk when only seven years old.
Robert Turnbull, Edinburgh, Glasgow, Paisley & Saltcoats.

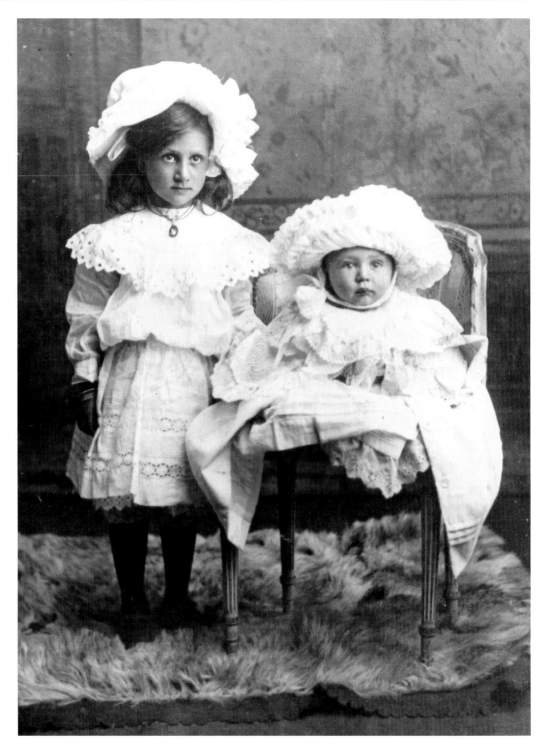

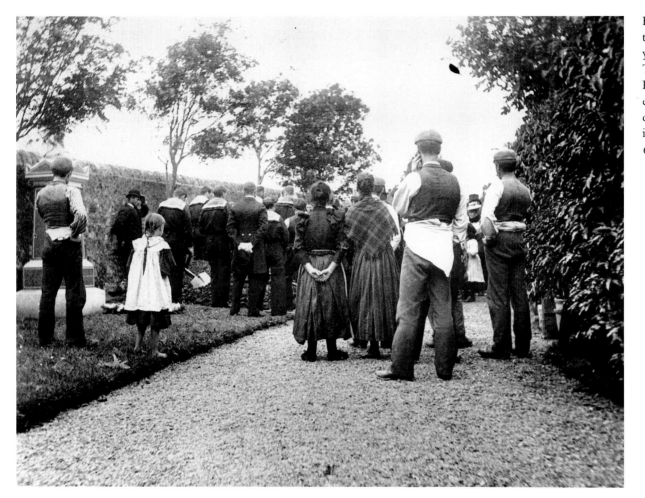

Feelings of fear and fascination seem to inhabit most of us, however young, when confronted with death. This naval funeral in Campbeltown's Kilkerran cemetery, Argyll, in the early 1900s has attracted a small crowd of respectful onlookers, including this young girl.
Charles & Dennis MacGrory

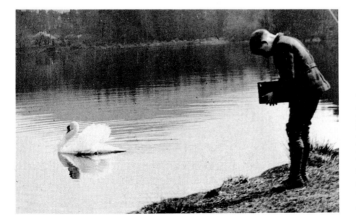

Alan Hood Wilson practising his photographic skills on a swan at Slipperfield Loch near West Linton, Peebles-shire in the spring of 1905; himself the subject of his friend Charles Graham's photograph. Alan later became the captain of Merchiston Castle School and went on to Cambridge University but, like tens of thousands of boys of his generation, was killed as a young man during the First World War, while serving with the 6th Battalion Rifle Brigade in France, on 15 March 1915.
Dr Charles W Graham

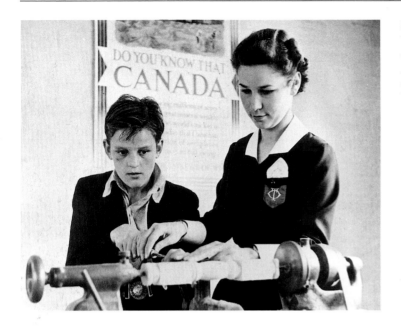

Sixteen-year-old James Colman being shown how to operate a wood-turning lathe in the occupational therapy department of a Glasgow hospital, in the 1950s-1960s.
Pictorial Press

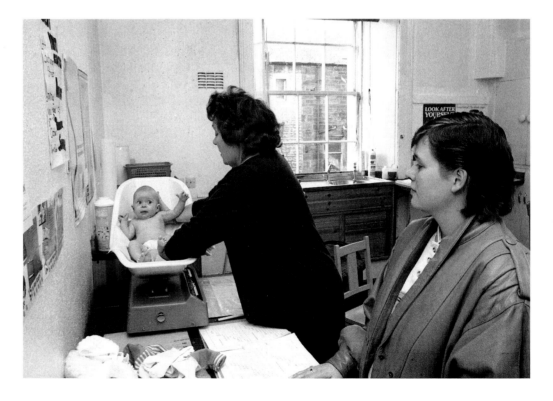

Four-month-old Nicole Galligan being weighed at one of the regular child health clinics run by Edinburgh health visitor Ann Stanton in 1990.
Ian Larner, NMS

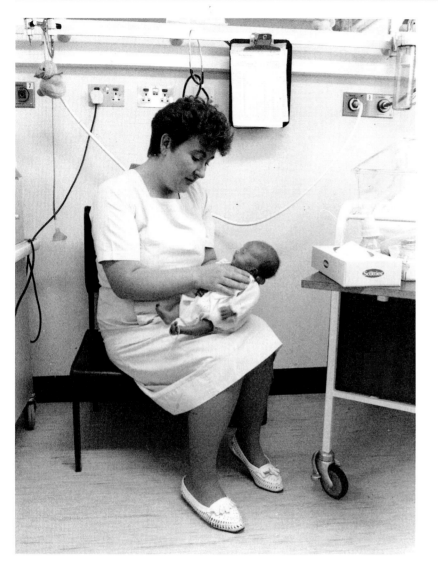

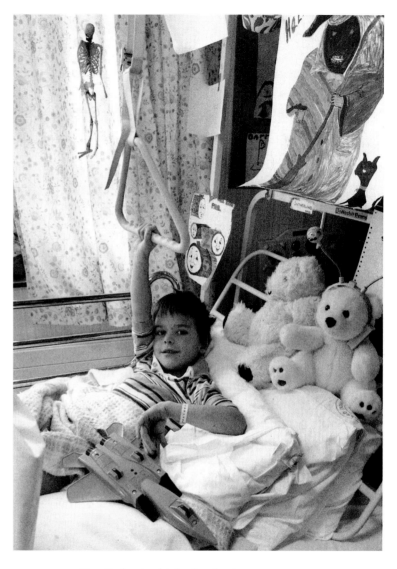

A very young patient halfway through his feed in the Special Care Baby Unit of St John's hospital at Livingston, West Lothian in 1990. It is only in the last few years that advances in medical science have enabled very premature babies to survive.
Ian Larner, NMS

Despite having his broken leg in traction this boy was enjoying himself in the playroom of St John's hospital Children's Ward in Livingston, West Lothian in 1990.
Ian Larner, NMS

Staff and pupils neatly arranged in front of Lauriston Special School in Edinburgh, about 1914. All the children's heads have been shaved; there must have been a major outbreak of head lice, ringworm or impetigo.

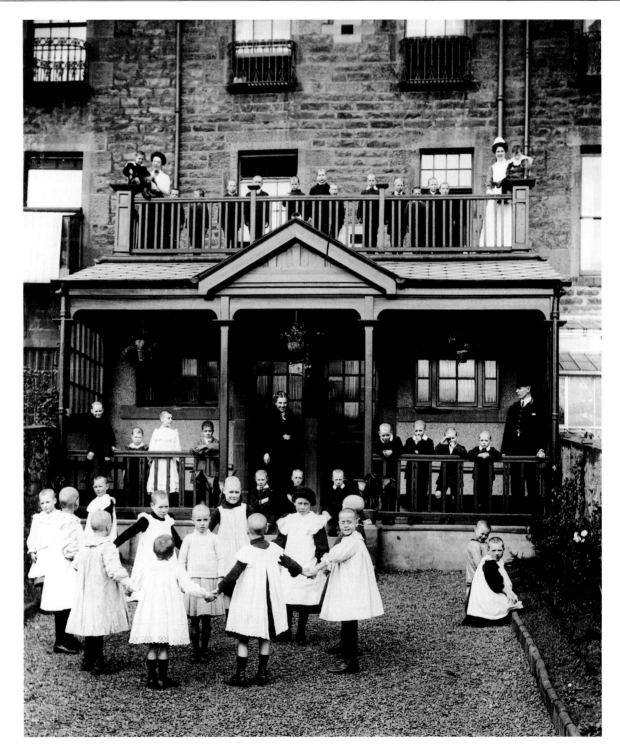

INSTITUTIONS

The Victorian age brought a deepening awareness of social problems, but solutions were left to philanthropists who tapped both the altruism and the vanity of their fellow-citizens. To be listed among the patrons of some popular charity conferred great social status. Before the rise of the Welfare State the destitute and unemployed relied on voluntary bodies for their survival, since the Scottish Poor Law benefited only those who were physically incapable of work.

Helping children without parents was a high priority long before Victoria's reign. There were endowed orphanages (confusingly known as 'hospitals') in many Scottish towns; these were eventually taken over by the local education authorities. Later thinking was against isolating children in such large numbers, and by 1900 the more typical orphanage would be one of the cottage homes set up by William Quarrier. Other residential shelters were run by the churches. Some of the inmates were not orphans but children taken into care, as memorably described by Jessie Kesson in *The White Bird Passes*. When old enough the children would be directed into the lower-paid workforce. A unique kind of orphanage was the Queen Victoria School outside Dunblane, founded to educate the sons of servicemen killed in the Boer War. Now rather less military in character, it still occupies its original buildings. The human-itarian movement also looked after disabled and mentally handicapped children, for whom there was almost no provision until the 1872 Education Act. Some voluntary societies also provided much needed breaks for city children and their mothers.

Well into the nineteenth century there was a fatalistic attitude towards juvenile crime: it was blamed on inherited vice or original sin, and severe punishment was thought to be the only way to deter offenders. Before the Children's Act of 1908 children under fourteen could still be imprisoned alongside adults; the birch was used for further offences while in custody. At Perth General Prison minors over eight spent a month in solitary confinement before being sent to the Juvenile section. The suicide rate was high, and many children ended up in the Imbecile or Lunatic Wing. Then as now, boys were imprisoned in much greater numbers than girls; but the age-tables for Magdalene Asylums for 'fallen women' suggest that poverty drove the latter into pros-titution rather than theft, and there is also some evidence of pre-pubertal child prostitution.

In the mid-Victorian period nurture began to overtake nature as an explanation for delinquency. James McLevy, the Edinburgh detective, who had more practical

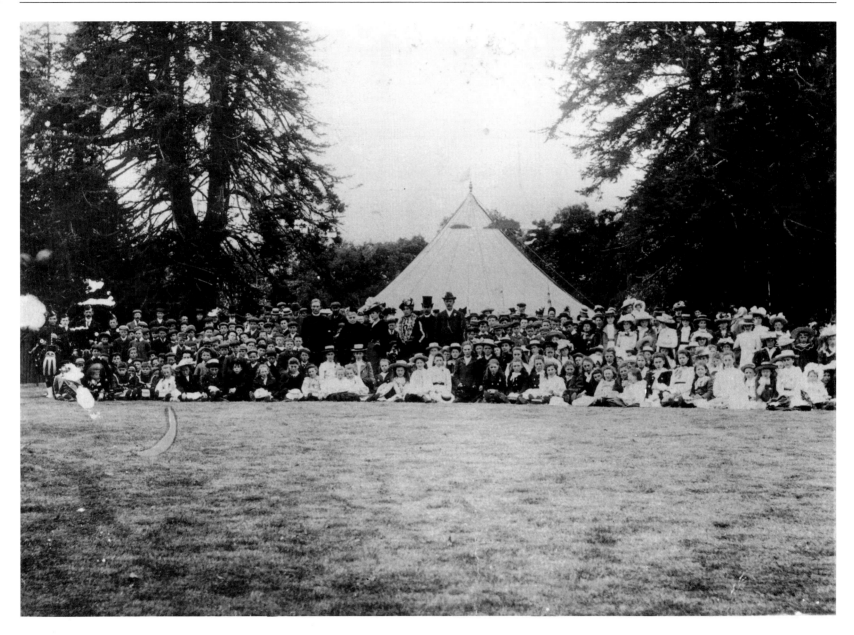

A Band of Mercy event organised at Delgaty Castle, near Turriff, Aberdeenshire in September 1902. It looks as though the entire community has been invited. The Band of Mercy was an organisation promoting temperance – abstinence from alcholic drinks – which concentrated its efforts on children.

experience than most, had no doubts about this:

> Let our Social Science friends just act up to the modern invention of anticipating the natural wants of human creatures, and the numbers of thieves and robbers will diminish further still... Society loses often what might become its sharpest and most intelligent members in these half-starved youngsters... if their cleverness had been directed towards honest and lawful undertakings. [1]

But, he concluded pessimistically,

> Were a thousand such cases sent up to the Privy Council, I doubt if their obduracy in endowing ragged and industrial schools would be in the slightest degree modified. [2]

It was the Church, led by Dr Guthrie, which tried to address the problem of so-called 'street arabs' in this way. The institutions they ran took in both girls and boys. Later on, Shoe-Black, Parcel, and News Brigades were organised to give older boys full-time employment, and by the 1890s there were four training ships run on the same lines. Prison Governors, troubled by the number of children in custody, were among the strongest supporters of the movement, and as a result schools and Houses of Refuge often turned into places of committal for juvenile delinquents.

During the nineteenth and early twentieth centuries youth sections were attached to a whole range of crusading groups, both religious and political. The Band of Hope drew in huge numbers of children all over Scotland, providing lantern shows and giving away bags of buns, oranges and biscuits at its weekly 'swarry'. The organisation had a robust attitude to getting over the temperance message.

> It was a great thing on a Friday night, the Band of Hope. They showed you shrivelled up livers and live worms curlin' up, demented and suffering, in jars of alcohol. [3]

The Band of Hope pledge card given to Cecil Turfus of Finstown in Orkney in 1903. Cecil was only four, and it is doubtful whether he ever promised anything of the kind. It was common at the time, however, for very young children to be signed up for the Band of Hope - another temperance organisation aimed specifically at children, which provided many exciting events and excursions. Cecil Turfus became a journalist for the Glasgow Herald, working first in Glasgow and then in the London office. His niece remembers him enjoying a 'quiet dram' on his annual Orkney holiday.

Most of the youth groups were affiliated to some Christian denomination. The Brownies and Wolf Cubs, the Boys' Brigade, the Girls' Guildry, the Girl Guides and Boy Scouts are among the best known; most of these are still in existence. Many kept a high profile with paramilitary accoutrements and command structures as they vied for young people's allegiance. Even in its early years the Brigade was sensitive to public awareness of the incongruity between its military appearance and its Christian affiliations. Henry Drummond (1851-97), Professor of Natural Science in Glasgow Theological College, was an enthusiastic publicist for the Brigade. The military trappings, he claimed, were 'the outward machinery ... a mere take-in... The real object is to win that boy for Christianity.' Parades and banners were adopted even by the less militant, and there was some odd poaching of each other's ideas: Jennie Lee (1904-88), brought up in a Fife mining village and later a prominent Labour politician, remembered her Socialist Sunday School with affection.

Today's young sophisticates appear less attracted than their predecessors to tying knots and joining in sing-songs with Brown Owl. Most of them seem to prefer more informal pursuits. The difference would have seemed trivial to early Victorians, who would have found it quite remarkable that children outside the upper classes should have so many leisure choices, or, indeed, the free time to enjoy them.

[1] McLevy, *Curiosities of Crime in Edinburgh*, p51.
[2] McLevy, *Curiosities of Crime in Edinburgh*, p167.
[3] Blair, *Tea at Miss Cranston's*, p132.

The lying-in or maternity ward at Craiglockhart Poorhouse in Edinburgh, between 1904-1914. Most of the women are apparently still awaiting the births of their babies. The poorhouse had been built in 1870 to replace the old Charity Workhouse at Bristo Port. It was designed to provide a 'comfortable home for the aged and poor', but also, according to *Greenlea Old People's Home. A Brief History* (Lothian Regional Council's Department of Social Work), to act as a reformatory for the 'dissipated, the improvident and the vicious'. It housed about a thousand people.

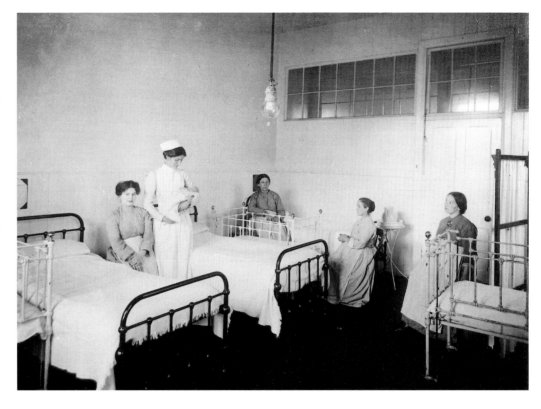

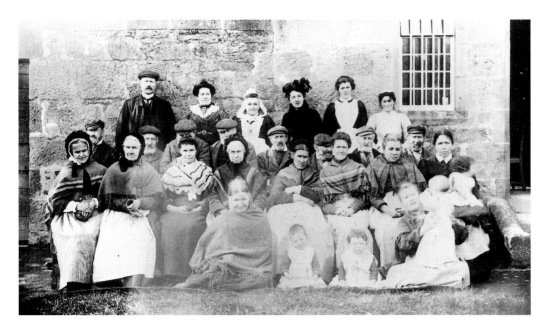

Staff and residents of 'Arthurville', the Easter Ross Union Poorhouse situated just outside Tain, in 1910. It was built in 1848 with accommodation for 176 'paupers'; the first in the Highlands and badly needed. During the famine year of 1847 when the potato crop failed, between 15% and 20% of the population of Easter Ross were forced on the poor roll.

Until social security was introduced, orphans, the homeless, single mothers, and the elderly who had no one to care for them were housed in poorhouses. Considerable stigma was attached to going to the poorhouse.

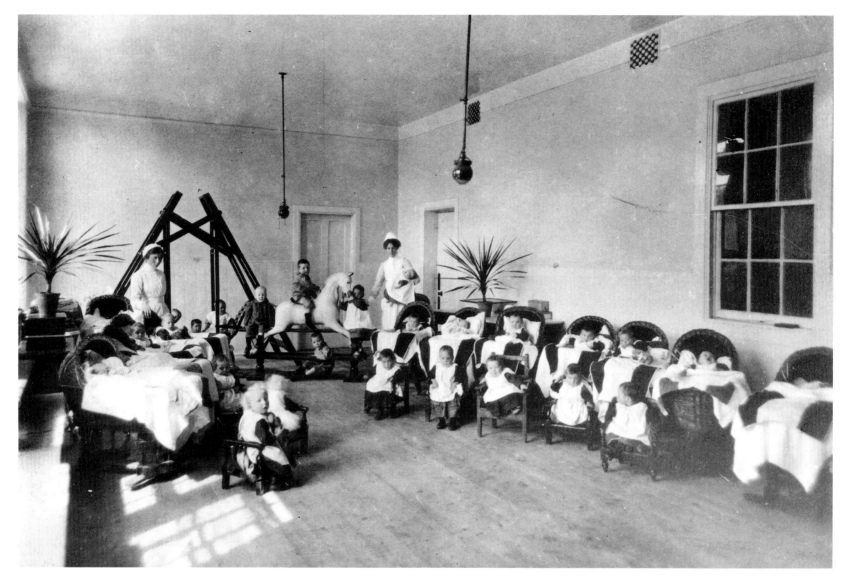

The nursery at Craiglockhart
Poorhouse in Edinburgh, between
1904-1914. This photograph was obvi-
ously taken with the aim of showing
the poorhouse in as favourable a light
as possible; nevertheless it does appear
to have been very well equipped for
the care of babies and toddlers.

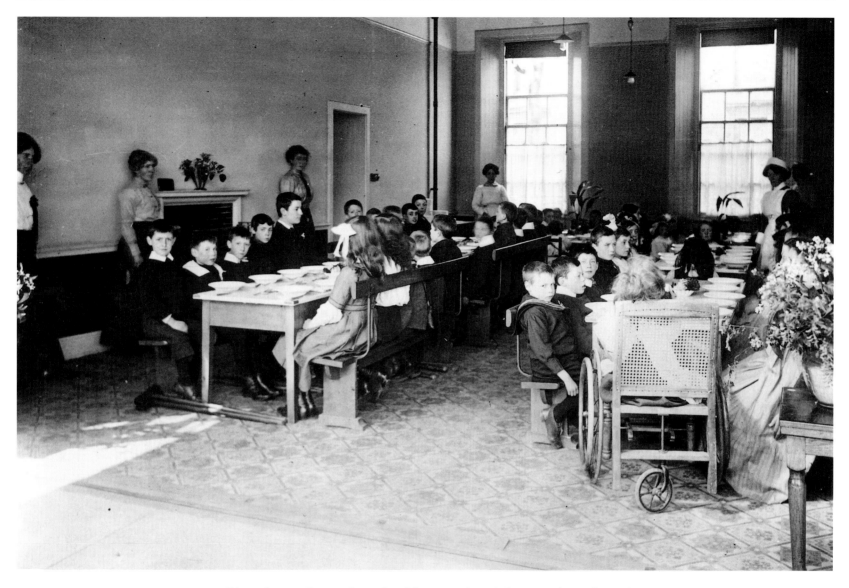

Dinner hour at Duncan Street Special School in Edinburgh, about 1914. The school taught children with physical handicaps and learning difficulties. Judging by the number of crutches tucked under the dinner table, many were affected by 'club foot' deformity or a bone infection such as poliomyelitis (infantile paralysis). The latter did not disappear in Scotland until the mass vaccination of the 1950s – one of the first and greatest achievements of the National Health Service, set up in 1948.

A Sunday School picnic in the Tealing area of Angus, sometime during the First World War.
The two girls at the right of the front row are Nan and Janet Mercer Dargie, whose father had the dairy farm of Leyshade, near Tealing. They were unusual in that their mother held out against them being taught to milk cows and thus be tied to the farm. Janet learnt to drive a car around the haystacks on the farm, never sat a driving test and drove until she was seventy. She devoted much of her spare time to youth organisations and was a great influence in achieving independence for many young girls, including the lender of this photograph Barbara Robertson, whom she helped bring up after Barbara's mother died when she was ten.

The Nitshill Socialist Sunday School float being prepared for the May Day procession in Glasgow, about 1960.
Basic socialist principles were taught in the Socialist Sunday Schools. In a much more cynical age we need to be reminded of the enormous importance which temperance, evangelical and socialist ideals and organisations had in the lives of a large proportion of the population during the first half of this century.

The very solemn members of Gorebridge Boys' Brigade, Midlothian, in 1907. The Boys' Brigade grew from Sunday meetings run by William Alexander Smith (1854-1915) at the Free College Church mission in Glasgow. To secure the boys' interest he decided to organise his class on military lines 'with a programme based on elementary drill, physical exercise, punctuality and cleanliness' (Checkland p57). The Brigade was launched in 1883 for boys aged between twelve and seventeen, and spread rapidly throughout Scotland and even overseas. Although the original Brigade was interdenominational, more narrowly-based organisations were soon set up in imitation, and in 1900 the complementary Girls' Guildry appeared.

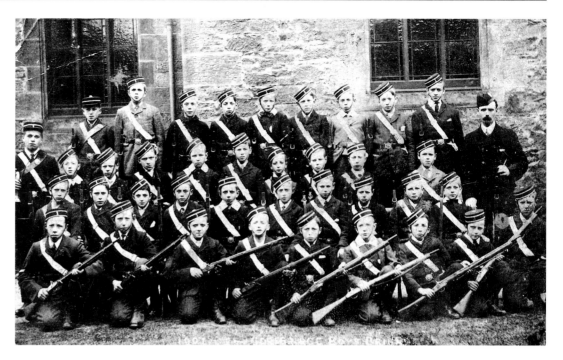

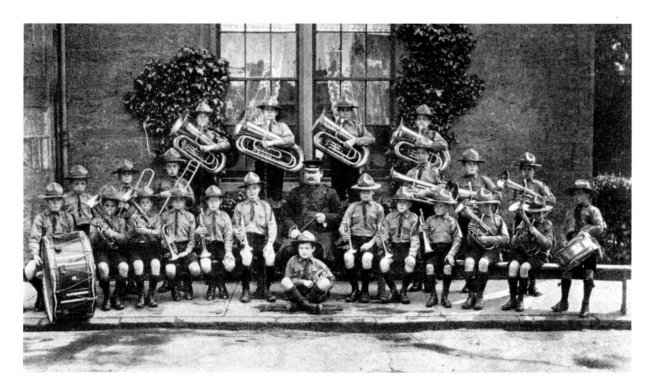

The 22nd (Fechney) Perthshire Boy Scouts band, about 1910. The postcard on which this photograph was printed states that the Scoutmaster and Bandmaster was H Wadsworth, who had served in the Coldstream Guards Band. The Boy Scout movement was started in 1908 by Baden-Powell; his wife founded the Girl Guides.

Ideal Studios, Perth

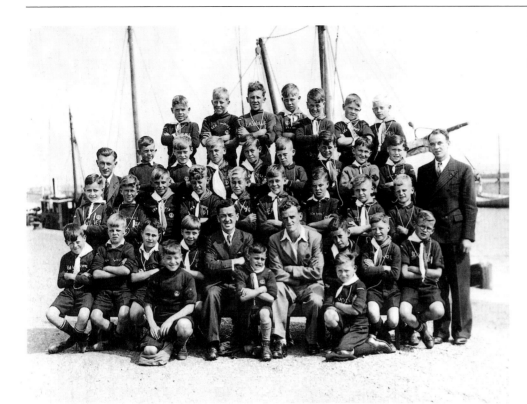

Some tough-looking Sea Wolves, of
the junior branch of the Sea Scouts,
from Nairn, in the 1950s.

Members of the Dunbeath Boys
Brigade from Caithness, on an outing
to Edinburgh about 1947-9. They are
gathered around the Heart of
Midlothian outside St Giles
Cathedral, presumably being told of
its significance and possibly having a
good spit at the same time. The heart
marks the site of the Old Tolbooth,
demolished in 1817. Spitting into the
centre has developed from a sign of
distaste for the prison into one of
good luck.

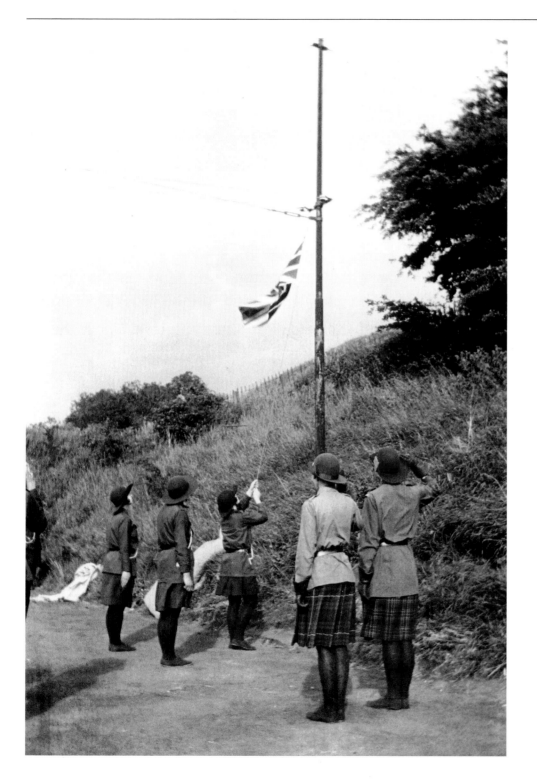

Taken about 1955, this photograph shows 82 year old James Thomson, one of the two surviving boys who had joined the Boys Brigade on the day it was launched - 4 October 1883. With him is his ten-year-old grandson, about to pass from the Life Boys to the Boys Brigade.
Scottish News Features and Photo Services Ltd

Currie Girl Guides saluting the Union Jack as it is hoisted up at Kinleith curling pond, Midlothian about 1930. A rather jingoistic patriotism used to be characteristic of the uniformed youth movements.

A distribution of food parcels to miners' children by the WIR at Lochore, Fife in September 1926, during the lockout which followed the General Strike. At the end of April, miners throughout Britain had been locked out by the coalowners until they agreed to wage reductions. On 4 May the General Strike started as other trade unions demonstrated mass support for the miners. The TUC General Council called off the strike on 12 May, but miners' unions refused, remained on strike and locked out. In the end, however, as the hardship experienced by the miners and their families grew intense, the unions had to call off the strike at the end of November and the miners' wages were reduced and working hours increased.

West Fife Pioneers (young Communists) in Lochgelly public park celebrating the first May Day Holiday (May 1) in 1929. The holiday, which celebrates socialist and labour ideals, was granted following a school strike demanding a May Day holiday the previous year.

After the meeting in the park, at which some of the children themselves spoke, they had tea and cakes and a sing song in Lochgelly Miners' Institute. Some of the children carried banners reading 'We demand the abolition of the strap' – success was delayed until 15 August 1987. The Communist Party found strong support in Fife and Clydeside; for many years the constituency of West Fife returned Willie Hamilton, a party member, as its MP.

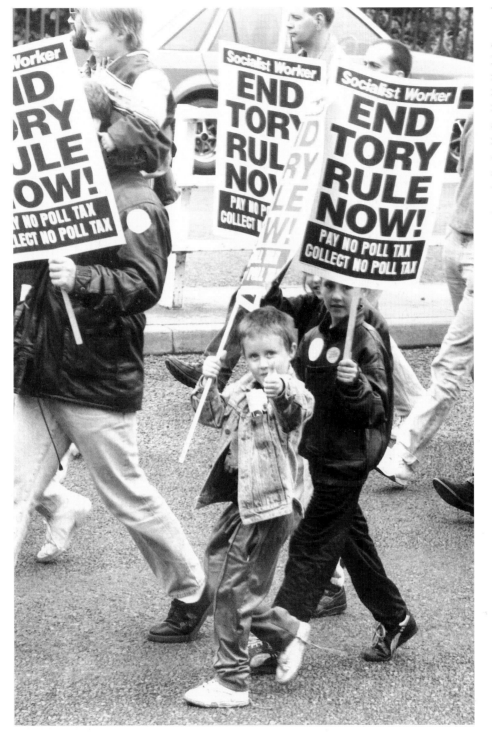

Young demonstrators taking part in a 'Scotland United' march demanding democracy for Scotland, in Edinburgh on 6 June 1992. The march started at the Old Royal High School (the site proposed for a Scottish Parliament) and ended with a rally on Leith Links. As can be seen from the banners held by some of the children, the issue of the Poll Tax was another matter at the forefront of their parents' minds.

Ian Larner, NMS

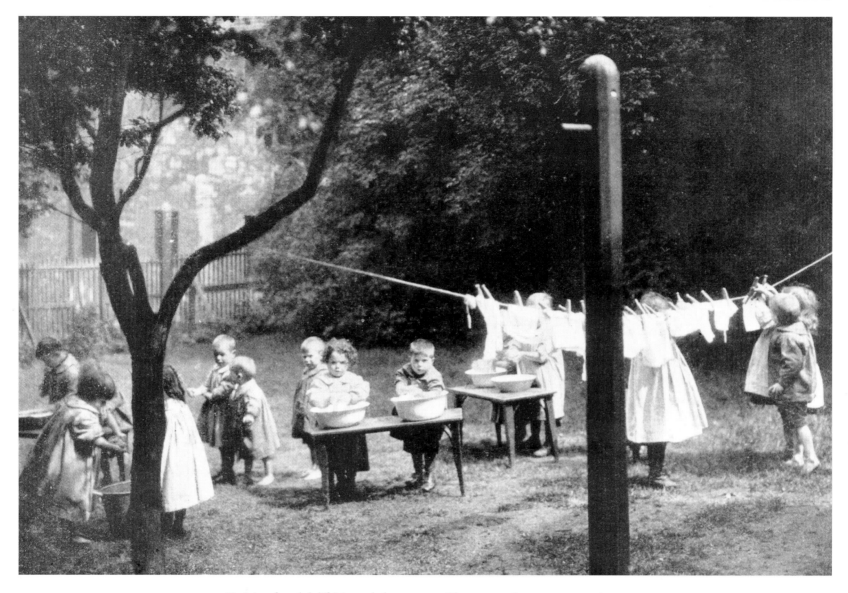

Training for adult life? Intently laundering doll's clothes at the free Kindergarten in Edinburgh's Canongate in 1917. Whether many of the little boys went on to do much laundry work as adults is another matter.

The apparently generous provision of this free kindergarten was probably to enable the children's mothers to take part in War Work.
F C Inglis, Edinburgh

ALL WORK

The stereotype is of young boys and girls forced up chimneys or dragging coal-tubs on all-fours along hot, ill-ventilated mines for fourteen hours a day. After such horrors were phased out by the Factory Acts, child-labour disappeared in Scotland — or did it? Children have always worked and always will, as we ought to realise when we lift our local free paper from the doormat.

A child's working career often began with work about the home. When large families were the norm, the eldest were inevitably expected to look after younger children.

> I was only ten when my sister was born — I washed her nappies and had to make soup and do anything that had to be done in the house to help my mother. [1]

Household chores, a much heavier burden before the arrival of electrical cleaners and washing machines, were handed out according to age and ability. When it was the family's turn to use the wash-house, the whole day would be spent in sudding, scrubbing, rinsing, mangling and finally hanging out the clothes and linen. If washing was taken to a local steamie, the children would trundle it there in a pram or trolley. On a daily basis, coal and wood had to be broken up for the fire and ash removed from the fireplace or range. Friday night was the traditional time to scrub down the house and make it gleam with black lead, brasso and lino polish. No one except the head of the household was excused, not even a grown-up daughter whose fiancé wished to take her out.

> My mother said in an outraged voice, 'On a Friday? Oh, no, Alan, she's got her work to do.' [2]

Country children learned their trade by being involved in farm work almost as soon as they could walk. In the nineteenth century, vast bands of Irish workers migrated from farm to farm between August and October. They were still employed as late as the 1920s in the potato fields, and their children, like those of travelling people, toiled beside their parents when officially they should have been at school. Until the Clearances, Highland areas saw an annual migration of women and children to the summer shielings with the animals. In the Lowlands, under the bondager system, the male agricultural worker had to bring along a team of assistants, usually his wife and children. This practice did not begin to die out until the last quarter of the nineteenth

century. Harvest time was the busiest season; before mechanisation everyone's help was needed. Even small children would be asked to carry out tea and scones to the shearers. The realities of country life were acknowledged in the prolonged summer holiday given to school pupils. Until quite recently it could be up to two months in length.

Tasks handed out might be a proud foretaste of adult status:

> When it came harvest time it was all horse-work of course and at night-time each boy claimed a horse and got riding it back to the stable, feeding it and taking it into the field for the night. [3]

Or it might imprint gruesome memories. Jenny Stewart recalled a time in her childhood when pigs and sheep were still slaughtered on the farm:

> The sheep was ... put on a sheep-stool to get its throat cut and the blood was allowed to run into a bowl under it ... It was my job to stir the blood and I would be boo-hooin' and stirrin' ... and me just a child ... it was bad, that. But it was your job. [4]

It was not only workers' children who had to give up time that today's adolescents assume to be their own. The trivial duties that so enraged Florence Nightingale were duplicated among the Scottish bourgeoisie. Between 'coming out' and getting married daughters were expected to help their mother maintain the family's status. They did this by being conspicuously at leisure, although convention insisted that they spend their time on social calls, entertaining, or genteel pursuits about the house. Not to comply was considered selfish, if not downright eccentric, in contrast to the indulgence shown to adolescent boys. The frustration of this group of young women was not relieved until they were able to enter the professions and service industries.

In poorer families it was essential that children should begin work as soon as possible. The 1911 National Insurance Act gave some security to unemployed workers but universal benefit and family allowances were a long way ahead. Children's wages were critical for the family budget.

> I loved the school but my father died at forty-four and my mother was left with seven of us. [5]

Eldest sons not infrequently had to become the breadwinners, and if a mother died the eldest daughter had to take her place. The tradition of sons and daughters not leaving home until marriage, which survived much longer in Scotland than in other parts of Britain, was based on necessity as much as sentiment.

> My first week's pay was ten shillins. In those days every boy went home and gave his mother the pay. I gave my mother the ten shillins and she gave me half a crown, which was two and sixpence, an I thought I was well off. [6]

The work that children took up depended on the local economy: van boys in bakeries, rivet boys in boiler shops, drawers-off in sawmills, packers in soapworks, machine-minders in furniture factories, labellers in mineral-water factories. [7]

Like most school leavers even those marked down for apprenticeship went into semi-skilled or casual work to fill in time before they commenced training at the age of sixteen. The turnover was immense, because boys were discharged before they could qualify for a man's wage. Their sisters made their way into the manufacturing industries or textile mills; until after the First World War their most common alternative was domestic service. By today's standards, the hours were horrifyingly long, but so were those of their parents.

Some children would be drawn into the family trade as soon as they were old enough to understand instructions. Among street traders and entertainers, itinerant tinkers, small craftsmen and closed communities such as the east coast fisherfolk, these children would stay at the same work for the rest of their lives, the only change being that as adults they would be paid for their labour.

> She left school at eleven to go to the fish at Macduff... Her mother took her to work at the sheds and she was so tired the first wee while they'd to take off the oilskin apron she wore for the wet, and her mother lifted her into bed. Then it was up at six o'clock in the morning and away for the whole day at the fish again. [8]

The extension of compulsory education led to children gradually withdrawing from the fulltime workforce. At least, that was the legal position. In many areas the school-leaving age was either unenforceable or unrealistic given the level of family income. The 1872 Act permitted a system of half-timers and exemptions which was not entirely abolished until 1936.

Part-time work for school children is as common today as ever. Recent legislation tries to regulate the hours that pupils work in term-time, but the limit is not always observed by shopkeepers who want cheap labour and children glad to take an early morning or evening job to earn some extra pocket money.

We must remember that the pressure to go out to work did not always come from parents. The day when girls put up their hair or boys went into long trousers marked the transition to adulthood and was impatiently awaited. Status has always been as powerful an incentive to work as acquiring money of one's own. It was used by Government at the beginning of the Second World War, when school-children were employed in filling sand-bags and sent to knock on doors for paper salvage. Berry-pickers in Scotland's soft fruit areas always included children, but after so many of the adults were drafted into the Forces they appeared in the raspberry fields in even greater numbers. Photos and propaganda newsreels of the time are remarkable for the number of children seen 'Digging for Victory' and engaged in other patriotic labour. How

many schoolchildren now know that the October holiday which shortens the autumn term originated in country schools during 'Hitler's War', when their grandparents helped bring in the potato harvest?

[1] Tollcross History Project, *Waters under the Bridge*, p113.
[2] Faley, *Up Oor Close*, p57.
[3] Blair, *Croft and Creel*, p95.
[4] Blair, *Croft and Creel*, p18-19.
[5] Blair, *Croft and Creel*, p109.
[6] Tollcross History Project, *Waters under the Bridge*, p5.
[7] Tawney, in Smout *A Century of the Scottish People*, p98.
[8] Blair, *Croft and Creel*, p35.

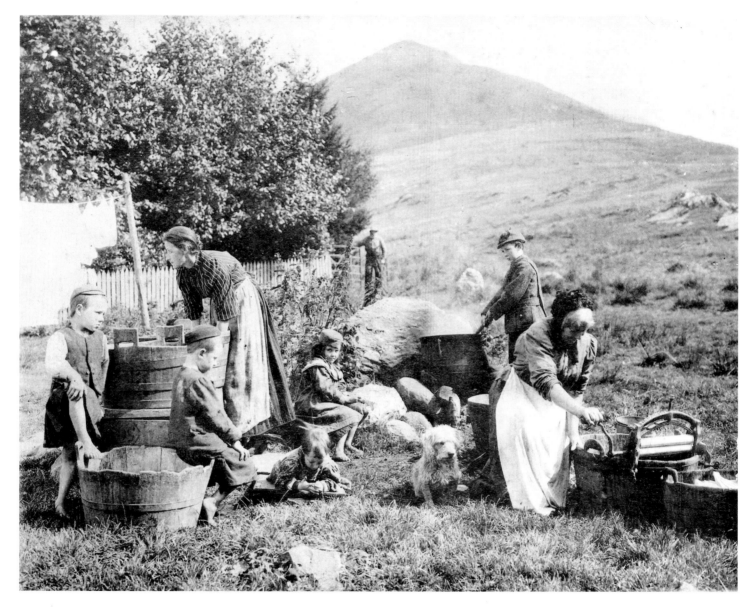

Helping with the washing, or at least pretending to, in Glen Fyne, Argyllshire in the 1880s. The little boy wearing the deer stalker does appear to be doing some stirring but the other children look extremely ill at ease in the presence of the photographer. The style of wash tubs, wooden staves hooped with iron, had been in use since the seventeenth century or before.

Jean Hay, the young maid, and Margaret Alma Grant in the garden of the United Free Church manse at Cornhill, Banffshire in about 1931. Alma's father, Rev John Allan Grant was the minister. Jean, who had been in Alma's older brother's class at school in Rothiemay, came to work at the Grants' after she left school at fourteen. She was a great companion for Alma who missed a year of school while recovering from measles and an operation for tuberculous glands. The girls, aged about fifteen and twelve at the time, read together and listened to big bands on the wireless.

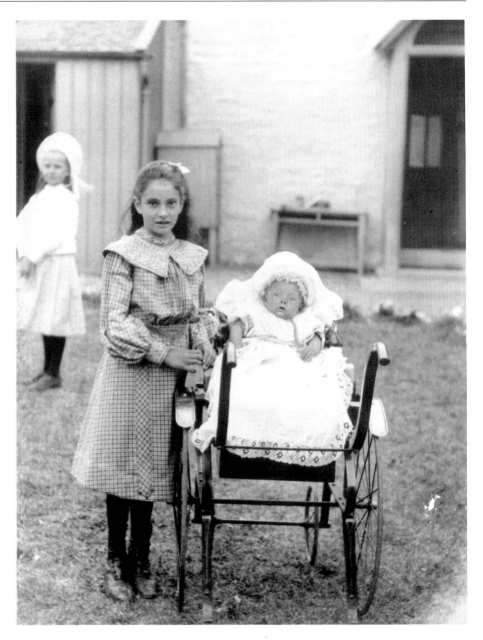

Babysitting a brother or sister perhaps, in the early 1900s. The photograph was probably taken in Greenock, Renfrewshire.

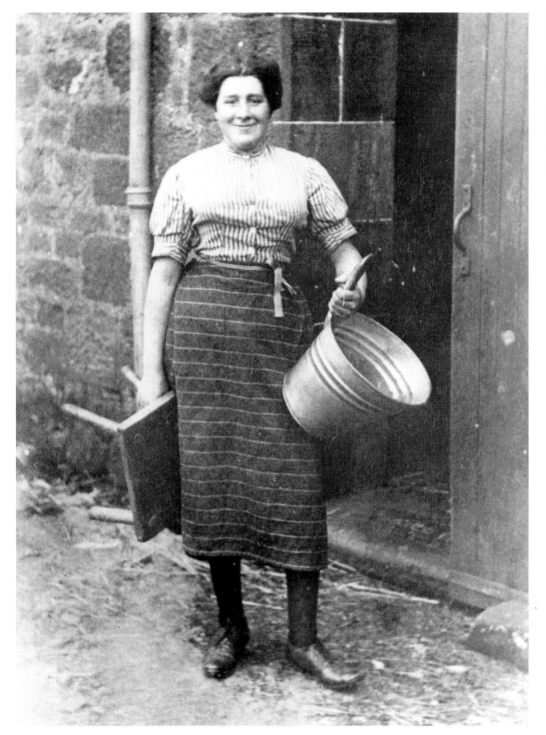

Grace Gillies, a Perthshire milkmaid, aged 15 in about 1910. Her stool, pail and striped apron were symbols of her trade. The one-handled pail, or 'milk cogg', is of the traditional shape, but galvanised iron or zinc has replaced the wooden staves which used to form the body of the pail. The original version can be seen in the photograph on p8.

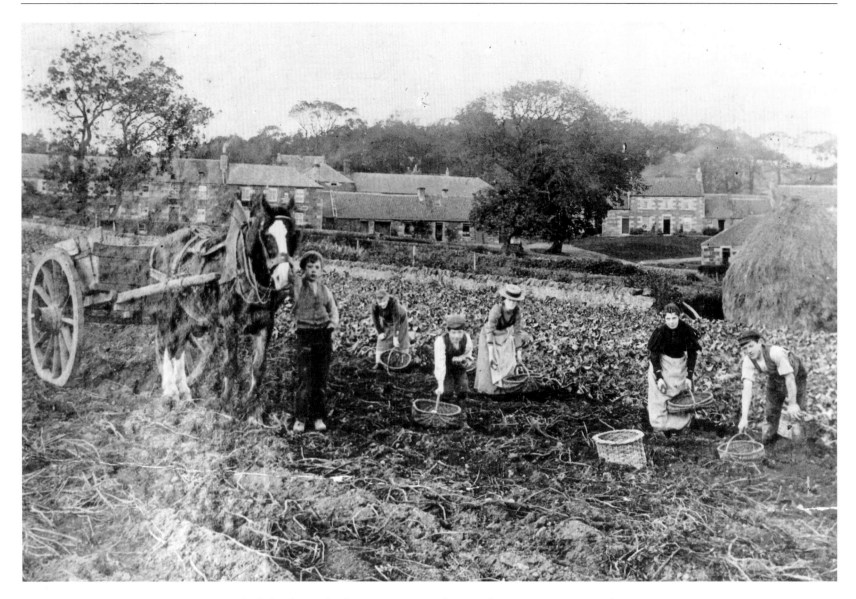

A back-breaking job of potato-lifting, in Fife about 1900. It seems to be a task for the young. A potato digger has turned up the crop and they remain to be lifted; the crop in the background is probably a separate planting of turnips. In some areas the October week school holiday is still known as the 'tattie holiday' after its origins in the need for many hands to help with the potato harvest.

Carting home the peats in Lewis, Ross-shire, c1960s. Peats were left out to dry after cutting and brought under cover towards the end of the summer.

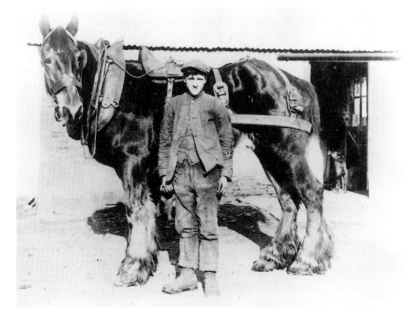

Jack Davidson, aged 13 or 14, during his first and only fee at Palcalk Farm near Alyth, Perthshire, about 1930. His 'nickie tams' - the leather straps tied below his knees - helped to keep his trousers from being muddied or at least relieve the weight of the mud. He was probably taken on as orra lad, or odd-job boy, and must have been proud to be photographed with one of the farm's Clydesdale horses. Jack disliked most aspects of farmwork, however, cattle especially.

Interviewed in 1978 he recalled how he preferred working with sheep: '...Father wis at Finavon, wi a lot o auld yows, an he took turnips tae a place, a lost bugger o a place, there's nae road till it ...Wull Finlay he took the turnips for sheep ...but he'd nae shepherd tae ging wi the sheep...so he asked faither ae day ...'I'm needin somebody tae ging an feed a puckle sheep'... I had tae cut them a (neeps) wi this hand cutter. So I got this - it wis twae pund a week he gave me, course I'd Setterday an Sunday ... Oh I never saw sic a lost hoor o a place, nae maitter, we gaed doon there, an the sheep, an I got on great wi the mannie, they were good te me... So efter I got that done, I gaed hame tae Finavon wi what was left o the sheep, an I never bothered wi onythin else but sheep from then on...'

He spent the rest of his working life as a shepherd in Angus and the Lothians.

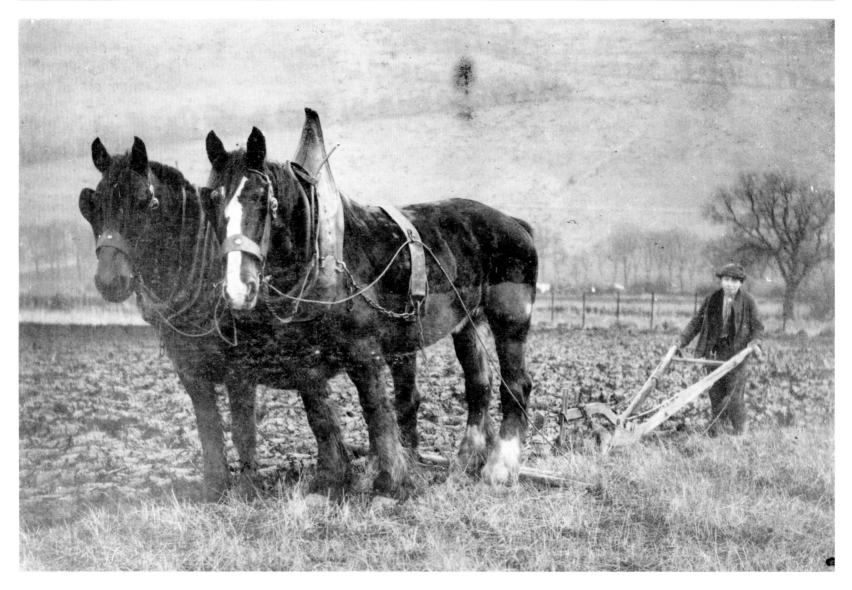

Young John Smith ploughing at
Hillton of Ballindean in Perthshire in
1915.

Jane Dewar, Sheena Dowie, Jane Anderson, and George and Willie Dowie displaying a splendid catch of rabbits arranged on a broomhandle at Pitcairlie Farm, Auchtermuchty, Fife in the 1930s. George is holding the ferret which must have helped unearth the rabbits.

Rabbits provided an excellent source of meat and fur, and culling them reduced their effect on farm crops. Although their populations have largely recovered from the reductions inflicted by myxomatosis, and culling is once again desirable, they have not recovered their popularity in the kitchen.

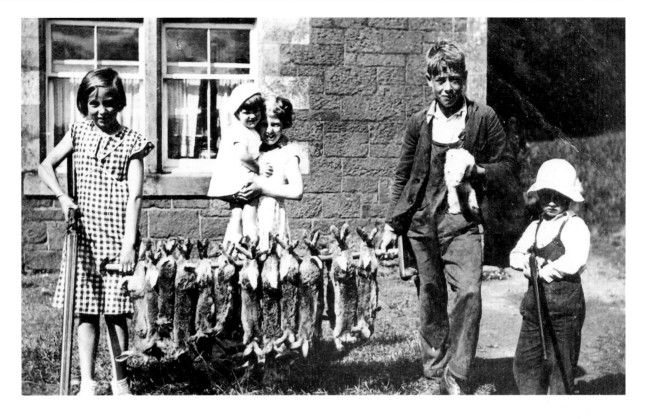

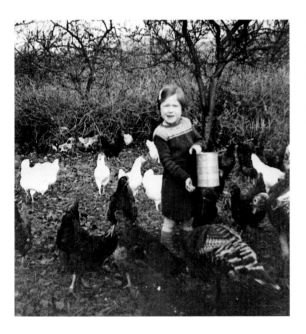

Feeding chickens and turkeys at Parkhead Holdings, Linlithgow, West Lothian, about 1940. Pig and poultry raising became more extensive during World War Two. It is still possible to see free range hens today, but uncaged turkeys are very rare.

Fun for All; except possibly this teenager waiting for customers for her stall at Aikey Brae Fair in Old Deer parish, Aberdeenshire in 1971. Aikey Brae had been the site of an annual horse market, said to commemorate the overthrow of the Comyns by Edward Bruce in the early fourteenth century. The ancient stock sale or feeing market has in many places been transformed into a modern funfair, but is still held at the traditional time each year.

Alexander Fenton, NMS

Staff at the Elderslie Tramway Depot, Renfrewshire in 1916. The large number of young women drivers and conductresses was a consequence of the First World War – after 1918 women had to wait until the Second World War to get these jobs back.

William McQuilkin, who became the Amalgamated Engineering Union's (AEU) Paisley District Secretary and a famous trade union leader, is sitting at the left of the front row.

Young apprentices and staff, thought to be at the Auchtermuchty distillery in Fife, about 1900. Their positions in the photograph no doubt reflect their places in the hierarchy of the distillery.

A young apprentice, posing for his photograph at Aberlady, East Lothian, c1900.
J Reid, Aberlady

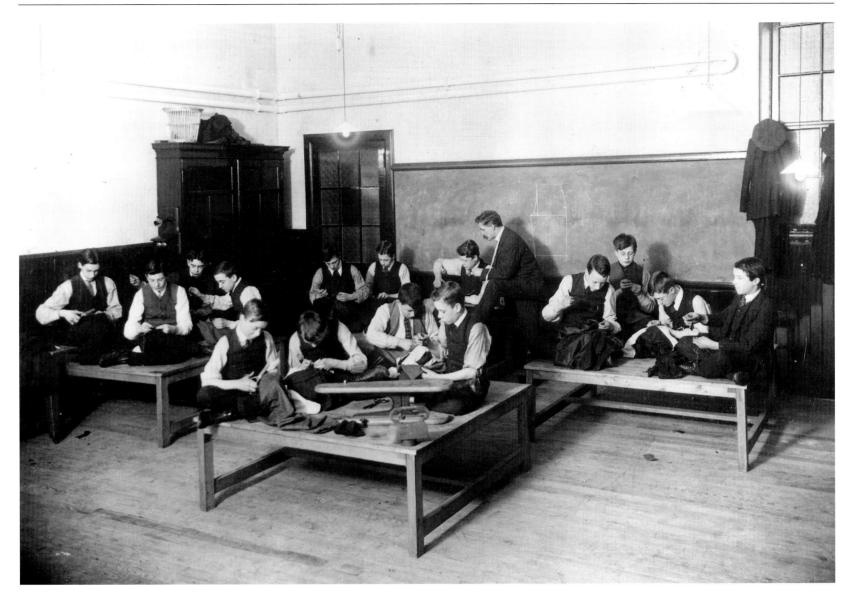

A tailoring class at New Boroughmuir school, Edinburgh, about 1914. An ironing board and smoothing iron, or tailor's goose stand on the front tailoring table. The boy being supervised by the teacher can just be seen using both ironing board and iron. Tailoring today still has a definite gender-related hierarchy whereby certain high status jobs, such as the making of men's suits, are performed by male tailors, while the bulk of workers employed in the clothing industry are poorly-paid female machine-workers.

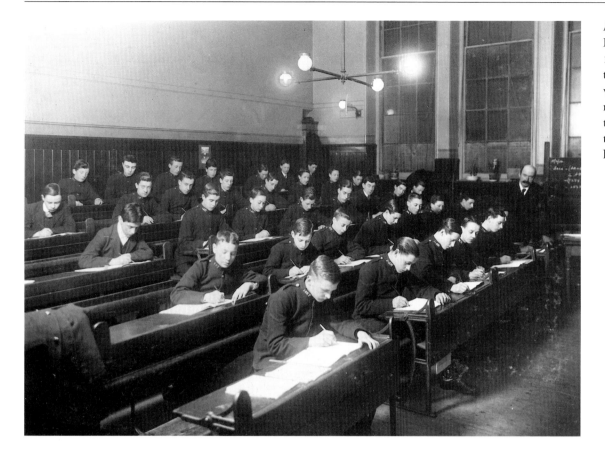

A telegraph messengers' class at Edinburgh's South Bridge school in 1914. Before the widespread installation of private telephones, telegrams were the fastest way to deliver a message. Messengers would have to take down and despatch answers, so they had to achieve high standards of literacy.

The storekeeper, Mr Simpson, showing catering students how to draw a half pint at the Scottish Hotel School at Ross Hall, Glasgow in May 1957. *British Transport Commission*

One small boy is too engrossed in what the salmon fisherman is showing him to take any notice of the photographer. The picture was taken at Balintore on the east coast of Ross-shire, about 1930.

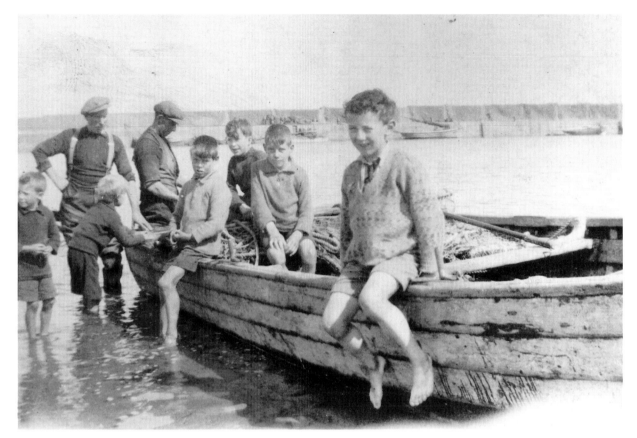

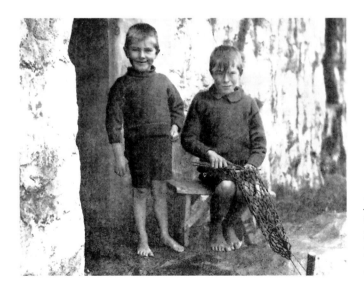

John and Donald Currie making nets for their father's lobster creels at South Lochboisdale, South Uist, Inverness-shire in 1932.
Margaret Fay Shaw

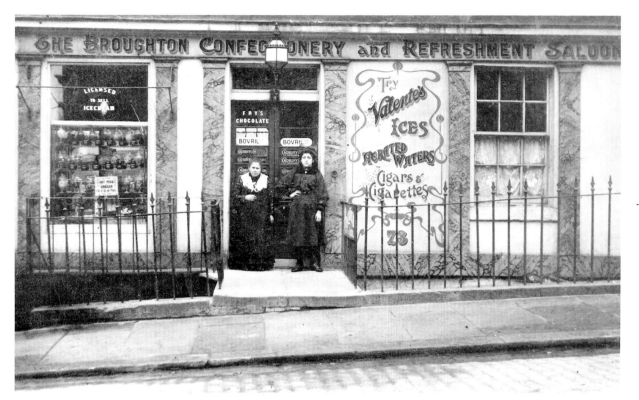

Mother and daughter, Maria Nicolina Pacitti and Maria Immacucato Valente, outside their shop at 73 Broughton Street, Edinburgh in 1907. Maria Pacitti, from a village near Naples, had married Sebastian Valente. The shop had been opened by her parents with money borrowed from a brother in Glasgow. It traded for twenty five years, and is currently a sandwich bar.
James Watt, Edinburgh

D Y Walker junior, standing in the doorway of his father's shop in Arbroath, Angus, about 1915. The clerkess is beside him, his father on the left and another butcher on the right. Whole carcasses were displayed on the street until the enforcement of modern hygiene regulations. The butcher's dog must have been both well fed and well trained!

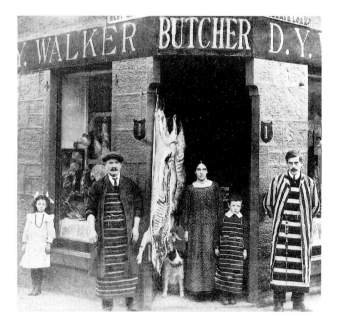

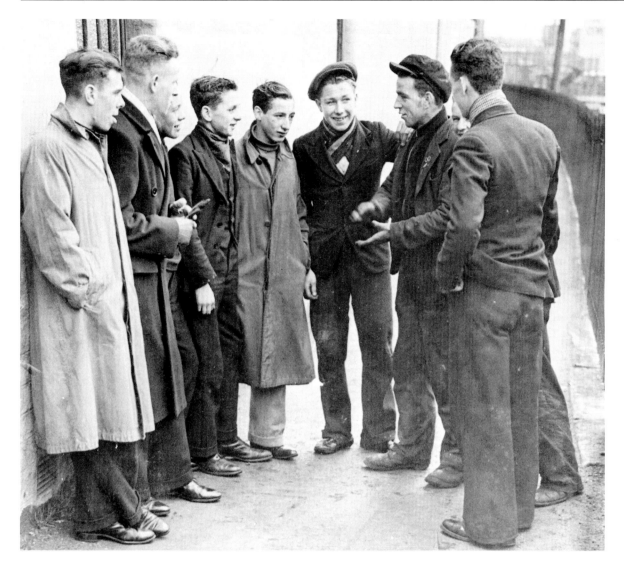

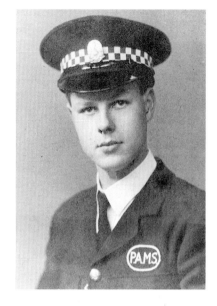

David Towns of Newton Mearns, Renfrewshire, serving with Giffnock police, aged 16 in 1943. He worked for the Police Auxiliary Messenger Service and his duties included operating the telephone switchboard, throwing the switch which activated the local air raid sirens and helping to check that houses were properly blacked out. His service with the PAMS ceased at the end of the war, but he was called up in November 1945 and served in the Royal Army Service Corps until May 1948.

Humour apparent even during the most serious of situations. These apprentices were on strike demanding better pay in Clydebank, Dunbartonshire during the 1930s. They are thought to be from either John Brown's shipyard or Drysdale & Co, pump manufacturers at Yoker.

James Russell

David and Roy the dog at St Fillans
Hotel, Perthshire in 1917. David was
probably the bellboy at the hotel.
Unfortunately the photographer did
not record his surname.
Katherine J MacFee

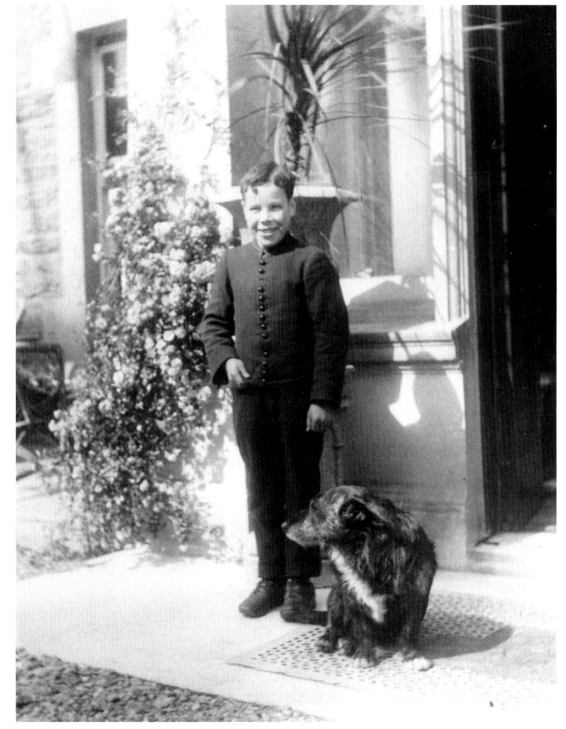

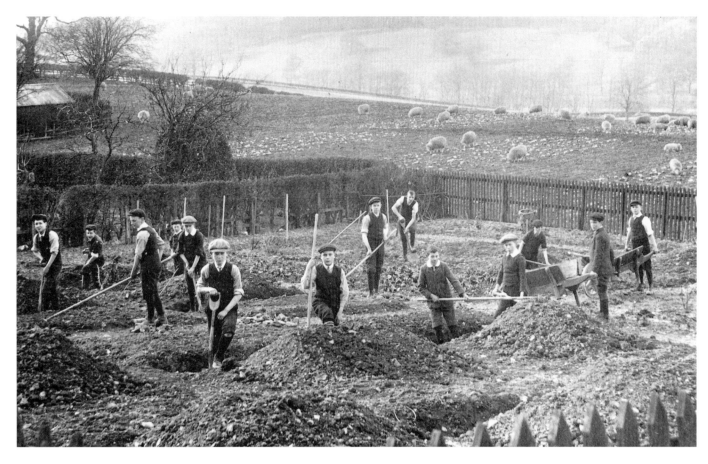

At work in the school garden at Lilliesleaf, Roxburghshire during the First World War. Every available piece of ground and any willing, or unwilling, hands were put to work to provide food both for the civilian population and for those serving in the armed forces.

Balerno and Juniper Green Girl Guides busy gathering sphagnum moss on the Pentland hills during the Second World War. A Brownie seems to have sneaked in on the right. Once cleaned and dried the moss was made into extremely absorbent first-aid dressings.

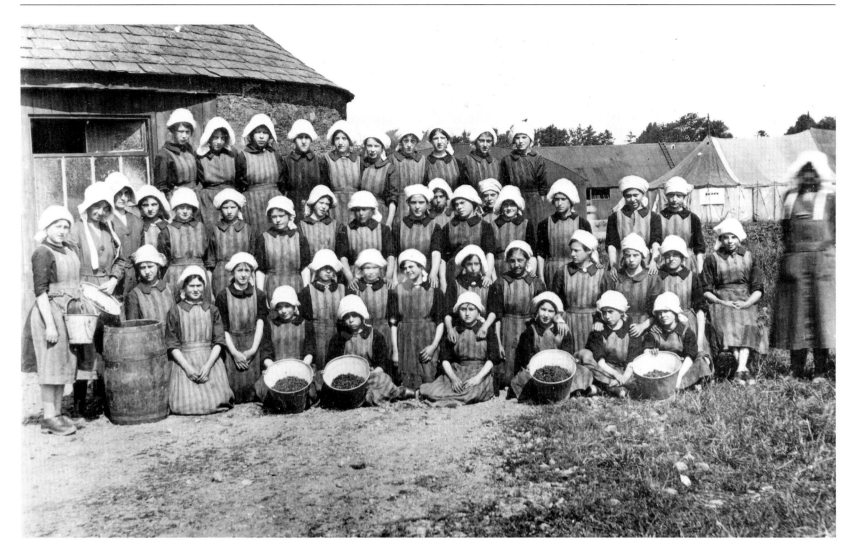

Young pickers, photographed during a break in the raspberry fields of Auchterarder, Perthshire in 1918. The uniform dress suggests that they were from a reformatory or industrial school. Laundry work was a common 'training' for such girls, and berry picking must have surely been preferable. An extract from J M Hodge's book *Raspberry Growing in Scotland*, (Scottish Smallholder's Organisation Ltd, 1921) gives an idea of the importance of children as fruit pickers:

...'it was soon apparent that the labour shortage which we had begun to feel in 1914 was to be serious in 1915. The situation was relieved in part by the Land Army, but more labour was required. Ordinary school children, apart from local children, had been found irresponsible. Boy Scouts, supposed to be under control were tried. Of 300, one half left within ten days...

Attention was turned to reformatory and industrial schools, because experience in pre-war days had taught us that institutional children were at least disciplined, and in this we were not disappointed,... in the second year of their sojourn in the fruit fields they had become so important as to constitute a kind of back bone to our picker population and we were throwing out feelers to find out whether, when the war was over, they would come back again.'

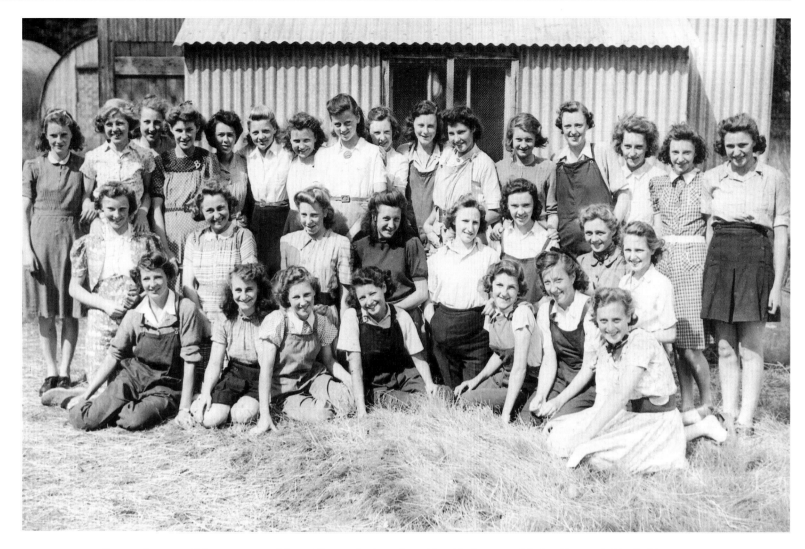

Some of a party of about seventy girls from the John Neilson High School in Paisley who were helping with the raspberry harvest at West Essendy, Perthshire in 1942. Not in uniform, they seem a much happier bunch than the previous group of girls.

Those who have been identified are: back row: Margaret Lyle (3rd), Gay Scott (5th), Evelyn Lawson (6th) Olive Campbell (10th), Betty Mill (11th), Diane Campbell (12th) and Sadie Barclay (13th); middle row: Graham Lyle (1st), Jean Risk (2nd),

Marion Provan (5th), Cathie McLeod (6th) and Margo Hussey (7th); front row: Stella Macgregor (1st), Margaret Miller and Betty Wilson. Can anyone shed light on the Graham (middle row)?

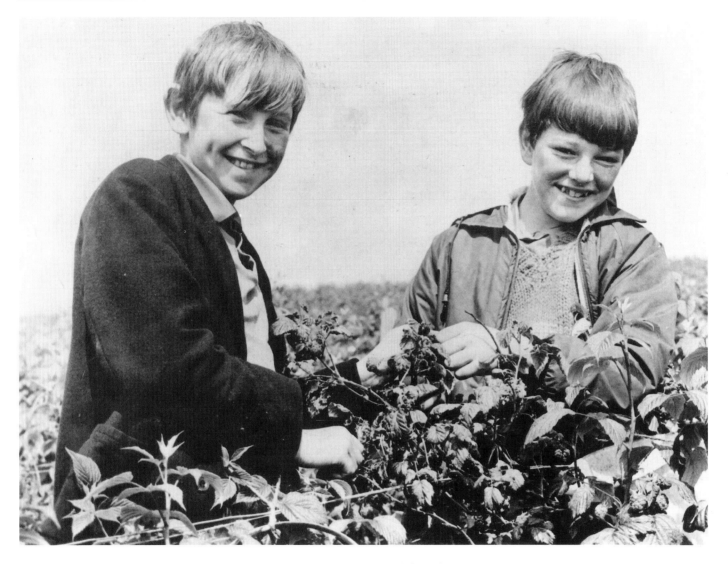

George Middleton, on the left, picking
raspberries with a friend in a field near
the Forfar Road, Dundee, in the
1960s.

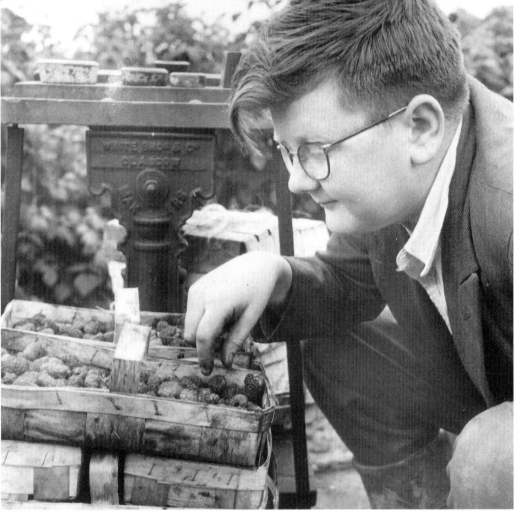

In this photograph, taken at Aldbar Castle, Aberlemno in Angus in 1957, a raspberry picker is preparing to taste some of his pickings – perhaps just to balance the scales?

P K McLaren

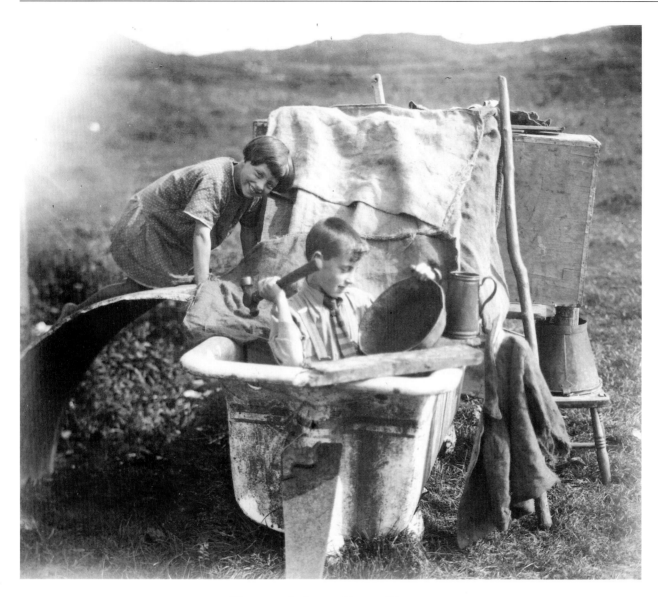

The crew of a fantasy ship, possibly at
Sanna, Ardnamurchan, Argyllshire,
in the 1920s. Imagination, rather than
elaborate equipment, often provides
the most satisfying kind of play.
Miss MEM Donaldson

TIME TO PLAY

Since the 1940s the lives of city children have been enormously curtailed by the increase in traffic and fears for their safety. Country children probably have more leisure than in the days when they were drawn into adult work from an early age, but are similarly affected. Compared with modern youth, their grandparents were unsupervised to a degree that is now inconceivable. They walked alone to and from school and provided they were biddable in such matters as meal and bedtimes were allowed to explore their own environment as widely as they wished. The country-bred could loose their energies over a vast area; burns were plundered for frogspawn and 'baggy minnons' (sticklebacks), there were trees to challenge and hillsides to sledge down in winter. Town children, though more restricted, used the streets and swing-parks as a playground and ignored the byelaws in their own back greens.

Games varied according to the time of year:

> One time ... it would be the whip and peerie and the diablo, another season, it was all peevers you played. Another time it was all skipping ropes, and that was how it went on.[1]

Girds and cleeks, conkers, bools (marbles), ball-games and yo-yo could be added to the list. A mysterious collective will brought them into fashion at the same time each year, whether played by girls or boys. Hide-and-seek, tig, and other team games without equipment were common to all children.

There were local names and variations, but the same games were played all over Scotland, some of them being centuries old. Many of the rhymes that accompanied them have the haunting quality of a Border ballad, but they can also be cheerfully vulgar. In *Golden City* James Ritchie transcribed the rhymes used by Edinburgh schoolchildren in the 1960s. Among them are recognisable versions of some in Chambers's *Popular Rhymes of Scotland*, but by then they also dealt with current events and icons of modern culture such as film stars, pop songs, advertising slogans and the characters in *Coronation Street*. This was a widespread and early development. A notorious 1936 murder produced the following parody at a Dunblane primary school:

> Red stains on the carpet,
> Red stains on the knife;
> Dr Buck Ruxton
> Has murdered his wife.

The term 'street-wise' would have had a totally different meaning for pre-War children. Quick-eyed opportunism was directed at cadging free rides on trams and water-carts or roping the door knob of one house to a door bell across the landing, followed by ringing the second bell — and run! A favourite sport was to slide a washer or safety-pin along an invisible thread and keep it tapping against a window pane. These forms of mischief were as universal as the singing rhymes, and in their own way testify to the strength of unwritten tradition.

The street provided other forms of free entertainment. Woodside, now a suburb of Aberdeen, was a small, self-contained community before the First World War and typical of many Scottish country towns. Andrew McKessock recalls that when he was a boy, there were regular visits by a German band, a dancing Russian bear, the organ-grinder and his monkey, street singers, melodeon players, Spanish dancers, and minstrel troupes — not to mention the Italian ice-cream sellers who gave him a free 'slider' when he helped push their carts around the streets. In most towns there was an annual visit from a travelling menagerie or circus; the best-known reminder is the St Andrews Lammas Fair, large sections of which still make an autumn tour round the east coast of Fife.

Children took as enthusiastically to the cinema as their elders, though the managers of these new entertainment palaces must have dreaded the Saturday matinees (entrance price one penny). They had to endure a great deal of rowdy scuffling and cat-calling, as well as the jeers of those reprimanded for smoking cinnamon-sticks, flipping cherry-stones, or squashing toffees and ice-cream into the seats. Usually the films shown were serials — Tom Mix, Fu Man Chu — with a cliff-hanging ending to bring back the audience the following week.

For most children toys were much fewer and simpler before the Second World War. There was a lot of improvisation, as with the hazardous but popular bogie cart, knocked up from orange boxes and old pram wheels. Proper toys were usually acquired as birthday or Christmas presents. Most prized was anything with a clockwork engine, particularly a train set, even if it did not have its full complement of sidings, platforms and carriages, which only the wealthy could afford.

> Then you also had dolls for the kids, and a scooter... You had tae be kind o' middle class tae buy a scooter. The usual toy was a metal mouth organ... Then you usually hung up your stocking, and you got an orange, an apple, an' tuppence in it, and that was that! [2]

In the sixpenny stores parents could buy smaller, cheaper versions of the porcelain dolls, Hornby train sets, teddy bears, tin-plate models and lead soldiers which are now collectors' items. Some of these imitations are in the same class themselves today. Penny novelties were sold by travelling salesmen, and collecting crazes probably began because the items were so cheap and could be augmented by judicious swopping.

Cigarette cards have gone for ever, but stamps are still popular and even now there are old-fashioned stationers who sell 'scraps' for pasting into albums. Space craft and other modern phenomena have joined the quaint Victorian angels, flowers, and baskets of fruit. Some annual festivals have changed greatly over the years. Making anything special of Easter and Christmas was once frowned on in Scotland because of their association with Roman Catholicism. Workmen took no holiday if Christmas fell on a weekday; festivities were reserved for the New Year. On Hogmanay, the night of December 31st, and at Hallowe'en, October 31st, children disguised themselves by blacking their faces and toured local houses begging for food and drink. Nowadays these guisers also appear on Guy Fawkes's Night and even go round singing carols. The amalgamation of English Christmas and Scots New Year has produced a week-long celebration, and the festivals of other ethnic communities have arrived to enrich our own tradition.

Local festivals have retained more of their original character. Riding of the Marches and street football are ancient parts of Borders life; Norse fire festivals and miners' galas are celebrated in other parts of Scotland. Children always play an important part: every properly organised gala has to crown its Queen.

Other annual events have more or less died out since the last war. The Sunday School treat was usually a day-trip to the sea, zoo, or rural beauty spot. Scores of old photographs record the high-points of these occasions when landowners opened their estates to an invasion of excited children and supplied them with tea and buns. A modern version is the taxi-drivers' annual outing for the children of Edinburgh.

Holidays away remained a luxury for most families until well into our own century, while holidays abroad were undreamed of except for the rich. Middle-class Victorian and Edwardian businessmen would send their wives and children away for a whole month to Dunoon or North Berwick, and travel down at weekends. A few days at the seaside in a boarding house or rented rooms was all that most other families could afford, and even that meant saving for months beforehand. There was no such thing as staggered annual leave; families went away, if at all, during the local Trades or Fair Week, and took it as a matter of course that this entailed a loss of wages.

Sea, sun and sand were enough to delight most children; it was a bonus if the visit coincided with pierrots or a comedian at the local beach pavilion. A more liberal allowance of sweets was expected and usually allowed. Old varieties were: soor plums, aniseed balls, ogo-pogo eyes, sherbet fountains (the sweet powder sucked up through a liquorice pipe), tablet, coconut ice, and Jeddart snails. McCowan's Highland toffee, which came in penny bars, could glue jaws together for ten minutes at a time.

Some families used up their holidays in day-trips by train or boat. The favourite was to board a Clyde steamer and sail 'doun the watter', enjoying the atmosphere of

Glasgow Fair Week. Edinburgh families made even shorter expeditions to Portobello or Cramond.

> As bairns, we used to go to Cramond on the train. The men went round the night before and stayed all night, and there was tents, and you all had your dinner at Cramond. And you got the train for three ha'pence. We used to shove the wee ones up in the luggage rack. [3]

However modest the trip by today's standards, 'We looked forward to it for weeks before we went and it was spoken about for weeks after we returned'. [4]

[1] Tollcross History Project, *Waters under the Bridge*, p198.
[2] Faley, *Up Oor Close*, p84.
[3,4] Tollcross History Project, *Waters under the Bridge*, p194.

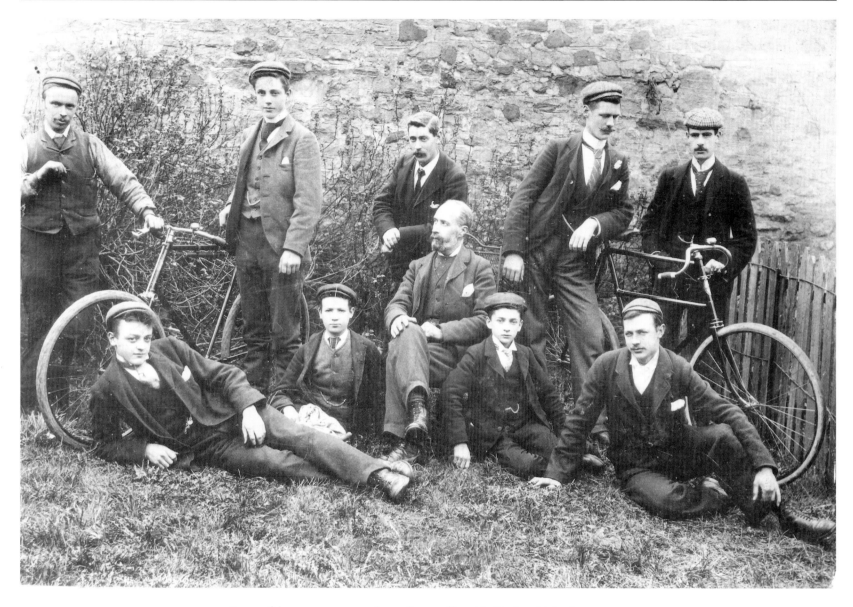

Some of the very smart members of Cupar Cycling Club, Fife, in the early 1900s. Bicycles were still expensive items that only the comfortably off could afford, and it looks as though the riders of these particular bicycles benefit from the comfort of pneumatic tyres.

Wearing fashionable bathing suits and bathing caps to explore the sea shore at Kinlochbeg, Ross-shire in 1896.

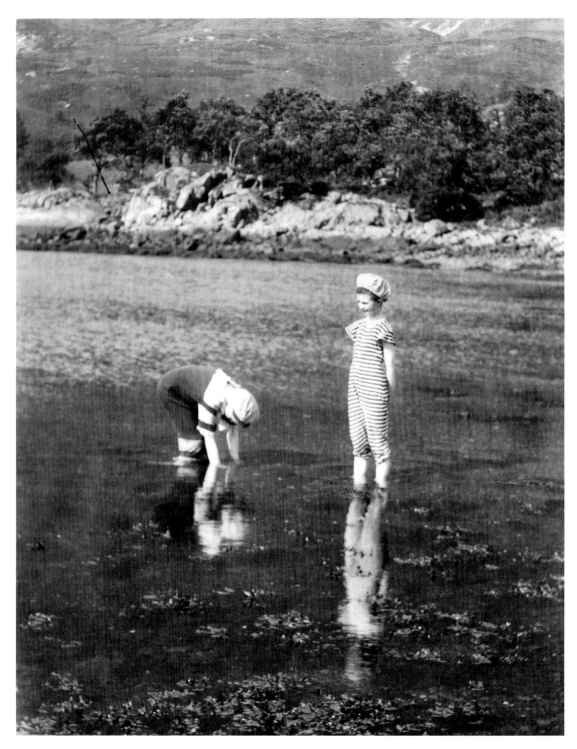

Local boys pestering tourist John MacFee in Bakehouse Close off Edinburgh's Canongate in July 1913. Inner-city children found their amusement in the activity of the streets, and a stranger penetrating such an overcrowded area naturally aroused a great deal of curiosity.
Miss Katherine J MacFee

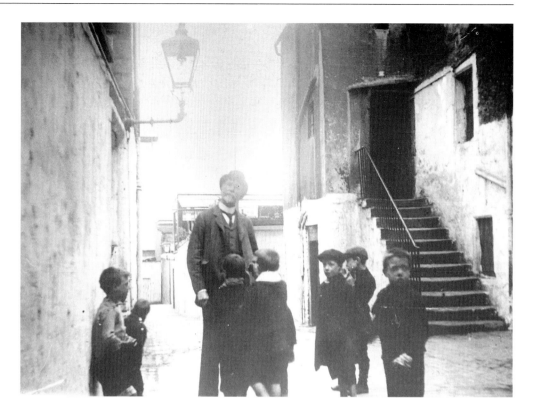

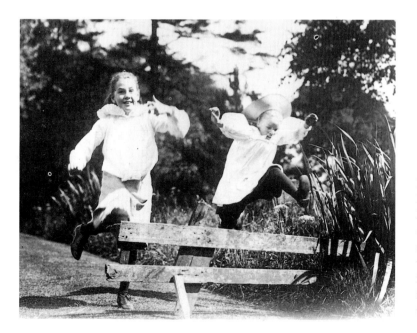

Helen Menzies, on the right, of Larchgrove House, Balerno, Midlothian, and a friend enthusiastically practising their high jumps over a rather dangerous-looking recycled wood hurdle, in the early 1900s. This is a very precise action shot considering the photographic equipment of the time.

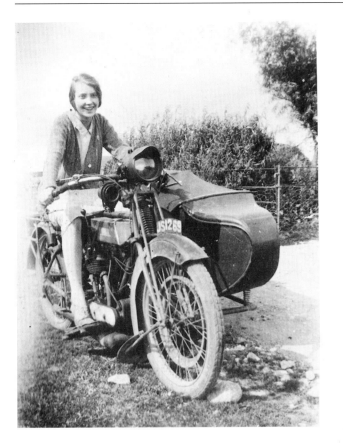

Miss MacLeod trying out the motor-
cycle and side-car belonging to the
local headmaster Mr Rennie, at
Tong, Lewis in the 1920s.

Bobbie Moffat from Motherwell, on
the right, posing with his friend in
their football gear for this studio
portrait taken in the early 1920s.
Bobbie was the brother of Sadie
Moffat (pictured on p134). Born
about 1910, he moved to Manchester
between the wars in search of factory
work. He died in the 1970s.

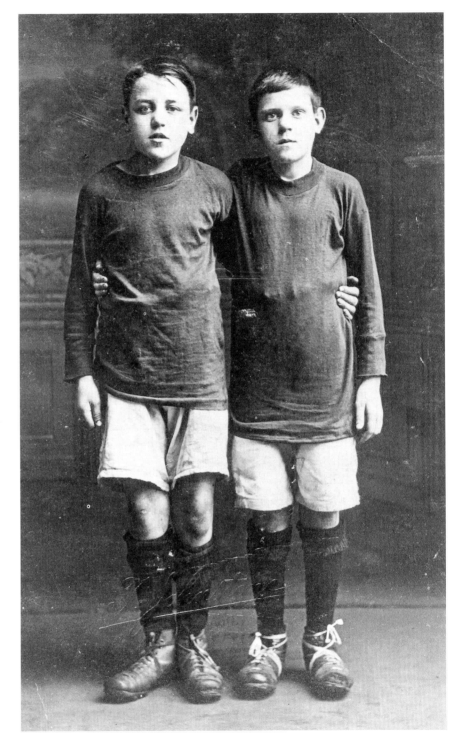

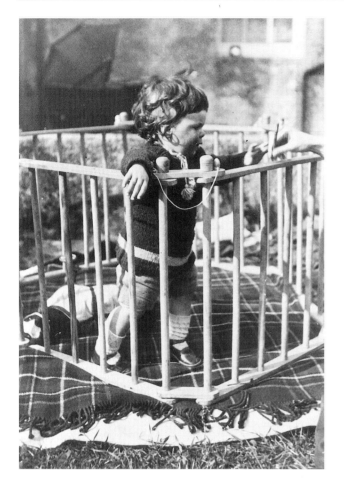

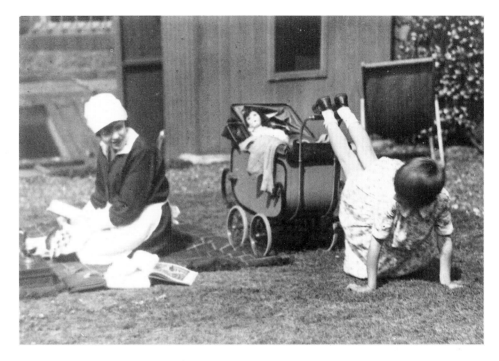

Ian's younger sister Joyce Graham showing off her athletic prowess with a doll's pram to Alice, the 18-year-old housemaid at 10 Lynedoch Place, Edinburgh, about 1930.
Dr Charles W Graham

Eighteen month-old Ian Graham, safely restrained by his play pen, about to grab the fountain pen offered to him by his mother; while his father captures the moment in Lerwick, Shetland in 1920. An older Ian also appears in the photograph on p28.
Dr Charles W Graham

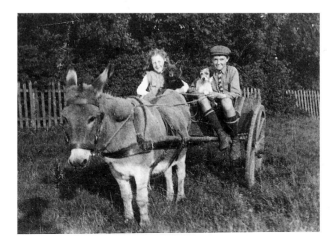

All aboard the donkey cart, possibly in Galloway in the 1920s-30s.

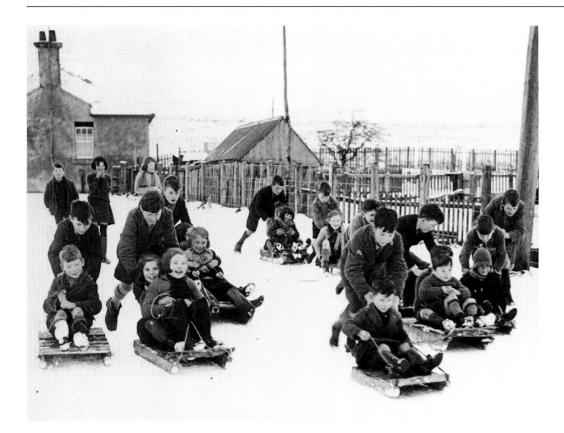

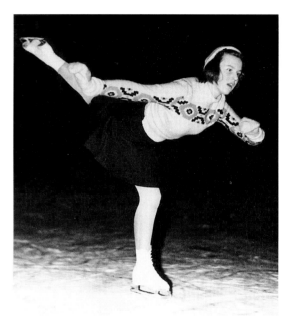

Caroline Dunsmore taking advantage of the ice-covered tennis courts at Kinnoull, Perth, in January 1939. *Star Photos*

Winter sports during the lunch hour at Dalwhinnie school, Inverness-shire in December 1935. A place where snow can still be guaranteed. The sledges look sturdy enough to be used year after year. *Keystone*

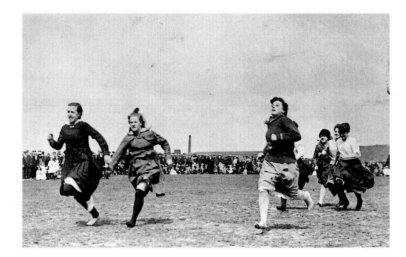

The senior girls' race at a miners' sports day in Motherwell, Lanarkshire, possibly held during the 1921 strike. Most of them have opted for running in their stockinged feet. Second from the left is 14 or 15-year-old Sadie Moffat, one of the six children of miner Hugh Moffat of Watsonville, Motherwell. She moved to the United States in the late 1920s with her husband, fellow emigrant James Miller. They settled in Buffalo, New York State where their four children and grandchildren still live. Sadie died in 1979.

The holiday camp chorus, c1950s. Only the harmonica player seems to be taking his music really seriously. Look out for the clothes peg drum sticks.
Robert McLeod

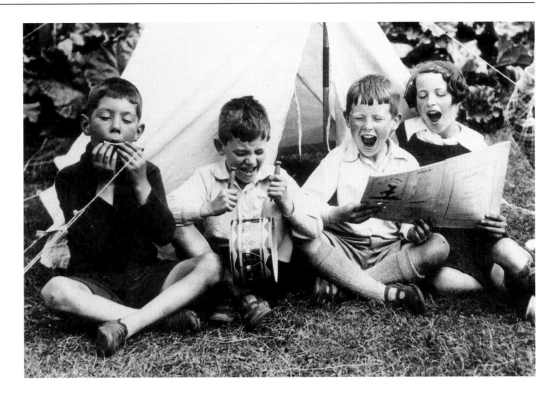

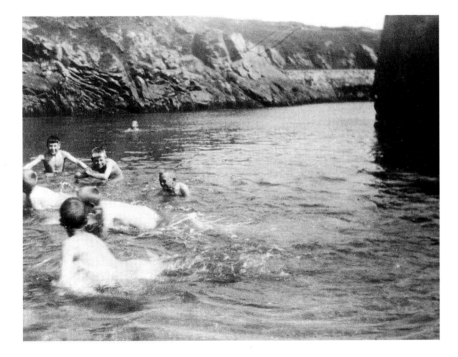

Skinny-dipping in the sea at Ness, Lewis, Ross-shire, c1960s. Though it is thought of as rather daring today, especially once out of childhood, until late Victorian times it was considered unmanly for men and boys to wear bathing costumes, even close to mixed beaches. Only the degenerate French wore bathing suits.

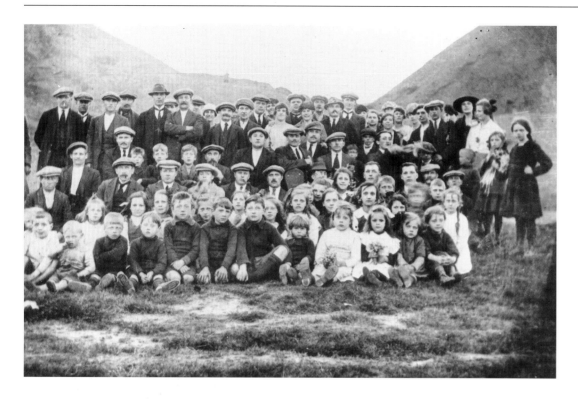

A Sunday outing and picnic for Lithuanian immigrant children and their parents, in Lanarkshire, about 1910. The bulk of Lithuanian immigration to Scotland took place between 1890 and the First World War. Most of the immigrants – 5,000–6,000 people – settled in Lanarkshire, where they worked in the coal and steel industry – a very different life to the mainly agricultural background from which they had come.

A very early photograph of Milnathort Flute Band, Kinross-shire, about 1865. The village also had a Brass Band. R L Wright and Dr W Haldane in *The Annals of Kinross-shire 1862-1870* remarked on an event in 1867:

'Handsel Monday (first Monday after New Year's Day) still retains a hold as the popular holiday in the opening of the year. Instrumental music at this time holds strong sway in the affections of our community, no less than three bands visiting the county town during the course of the day. The Juvenile Flute Band, we read, had a pleasant meeting with that of Milnathort at 5am!'

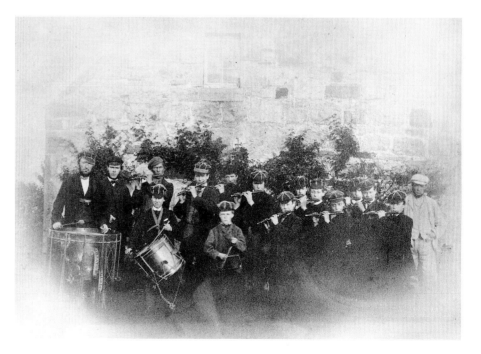

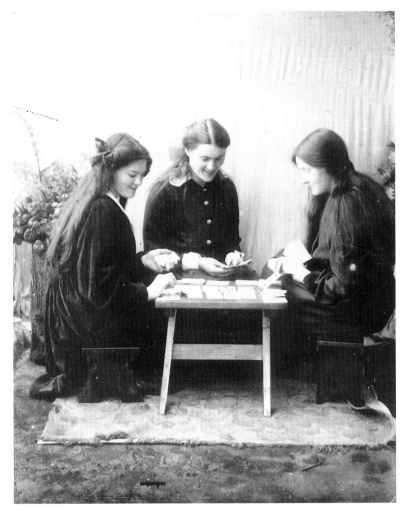

Lorna, Yarta and Ida Saxby of Halligarth
House, Baltasound, Unst, Shetland play-
ing cards for a posed photograph taken
by their surgeon and JP father in 1916.
The table was made by their uncle
Captain Stephen Saxby. The relaxed ease
of the sisters comes through, despite the
artificial 'Three Graces' pose - a tribute
both to them as sitters and to the photog-
rapher.
Dr T E Saxby

A toddler posing with her home-made
toy in May 1926. The toy produced a
clucking noise as it was pulled along by
the string, and the stick no doubt added
to the overall effect. An unusual use for
the discarded pram wheels that more
frequently provided locomotion for the
coveted 'bogie-cart'.

A studio portrait of a toddler, from Ness in Lewis this time, in the early 1900s. The apple is presumably being used to keep him from getting too impatient. The wooden horse may well have been one of the photographer's props, rather than the child's own toy. His shorts look very comfortable, but he is wearing stout high-buttoned boots.

Jack, Laura and Isabel McNicol of Kinnesswood, Kinross-shire, about 1910. Only Jack looks entirely at ease facing the camera of James Scott, a St Andrews architect who owned a house in the village. His little, frowning, sister has not been able to stand quite still enough and is slightly out of focus as a result. All three children have been provided with something to hold, perhaps supposed to express their individual interests or talents: a tennis racket, a bunch of flowers and a periodical.
James Scott

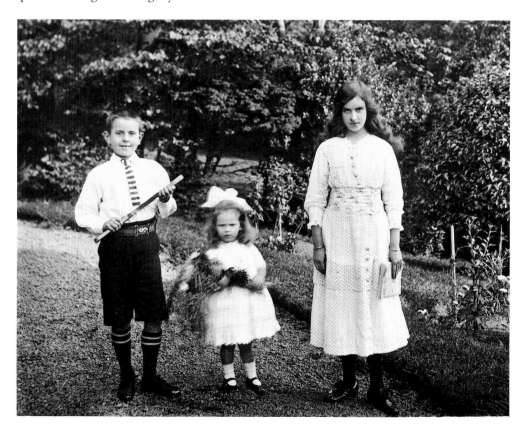

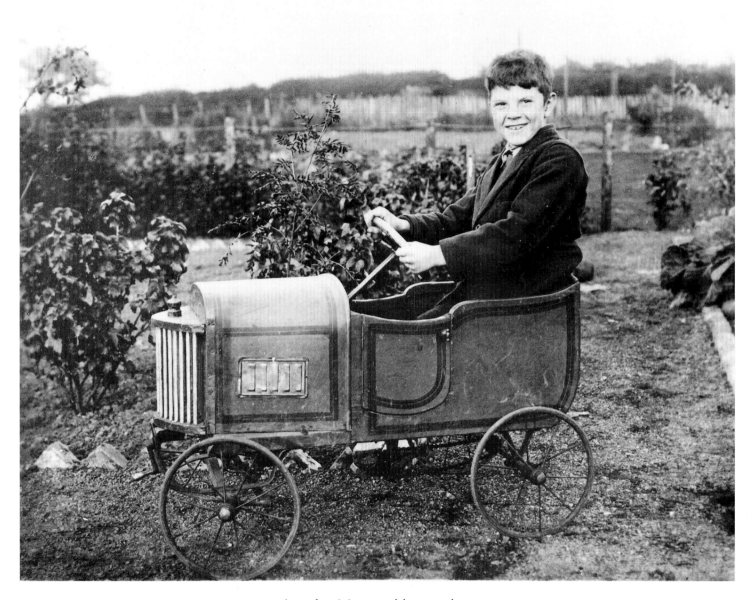

An early miniature pedal-operated
motor car driven by a delighted
Norman in the back garden of Glen
Elm House, Currie, Midlothian in the
1920s-30s. Unfortunately we do not
know the boy's surname.

Seven-year-old Louise Wilson showing off her bicycle outside Harrison Park, Edinburgh in 1946. She has very fond memories of this bicycle:

'For my seventh birthday this wonderful pale blue BSA bicycle, complete with saddle-bag and bell, arrived. Made before the war, it had been discovered in the stockroom of an Edinburgh cycle shop. As cloth-ing was still scarce after the war, my shorts were made from my aunt's skirt cut down. I was in such a hurry to try them out that I put them on over my home-made dress to have my photograph taken.'

Just before World War Two a bike like this cost £3 - quite a sub-stantial amount. Louise appears as a baby on p17.
Frank Wilson

Gordon and Sandy Ingram putting the finishing touches to their model boat at Wetwards, Drumblade, near Huntly, Aberdeenshire, about 1930.

Feeding the ducks at Rouken Glen, Renfrewshire in June 1937. This was a favourite day out for the Hardie family from Breich in Midlothian. Sarah Hardie is with her children Sadie and John and half-sister Daisy Prasher.

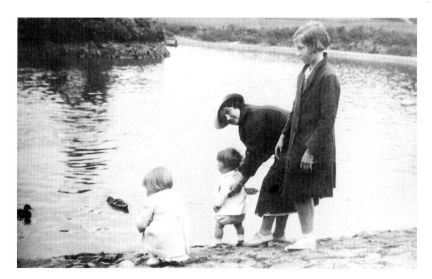

Sandcastle building and excavation work in progress on the beach at Peterhead, Aberdeenshire, in the early 1900s. The many layers of clothing worn by these well-dressed children must have become full of the most itchy sand. Bathing suits apart, leisure clothing for children is a comparatively recent development.

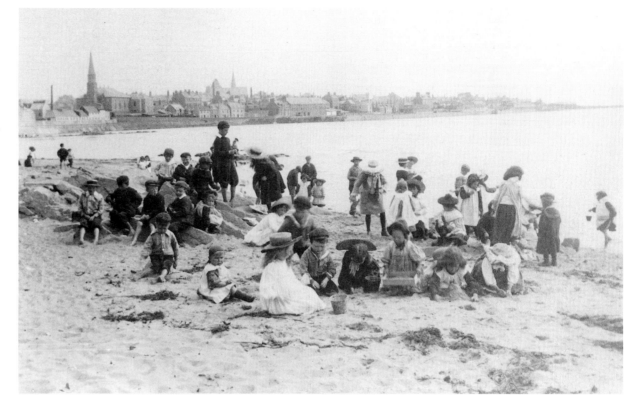

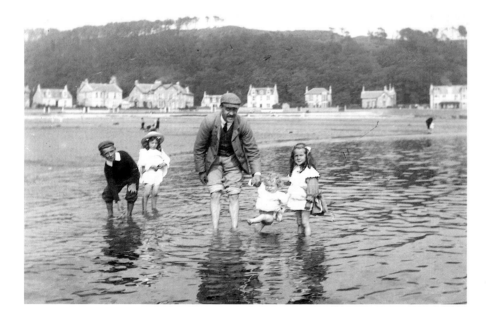

Holidaying at Millport, Great Cumbrae in about 1907. The resort was a favourite for the Jenkins family from Edinburgh. George and Jean Jenkins are on the right.
George Jenkins

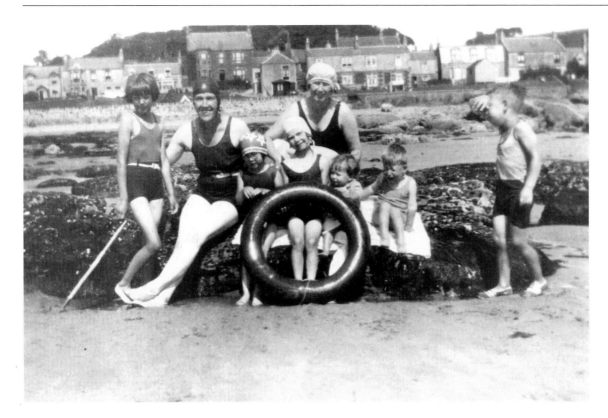

Two Edinburgh families on holiday in Lower Largo, Fife, in August 1935. Grace Murray Slee, with her arm around her niece Catherine Murray, sits next to her daughters Dorothy (pictured on p16) and Joan. Her friend Mrs Rogers is with her three children. The Slee family first took a cottage at Largo in the early 1930s when their doctor recommended sea air as a sure cure for whooping cough. They returned for a month each summer until the outbreak of war in 1939. Mr Slee came when not on duty and for his annual week's holiday. The large rubber ring was great fun in the water, until Grace threatened to sail off to Canada in it.

The expense of a seaside holiday was justified by bathing in temperatures that seem almost intolerable today. As consolation children were usually provided with a 'chittery bite' to eat after their bracing dip.

Sadie and John Hardie again -this time on the beach at Portobello in 1937. Several families from the village would make the day trip together; first catching the train to the Caledonian Station in Edinburgh, then on to Portobello by tram.

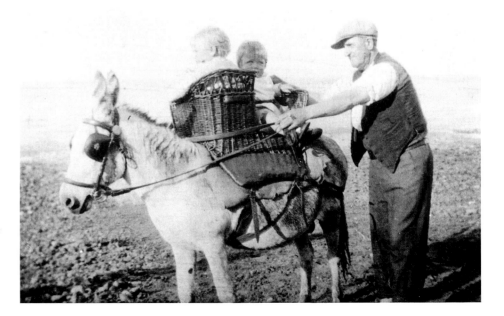

Mother and children splashing about.
Possibly at Rothesay, Bute in the
1950s–1960s. Again it looks rather
cold and windy.
J Scrimgeour

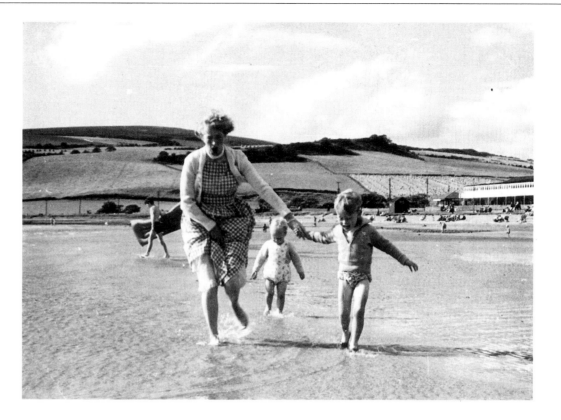

The paddling pool on Portobello
promenade, Edinburgh, in 1965. The
stance of the small boy in the centre
seems to show that it wasn't quite as
warm as it looks.
John MacKay

Seeing where they were going, or
indeed going anywhere at all, must
have been rather difficult for these
Halloween guisers at South
Lochboisdale, South Uist, Inverness-
shire in 1932.
Margaret Fay Shaw

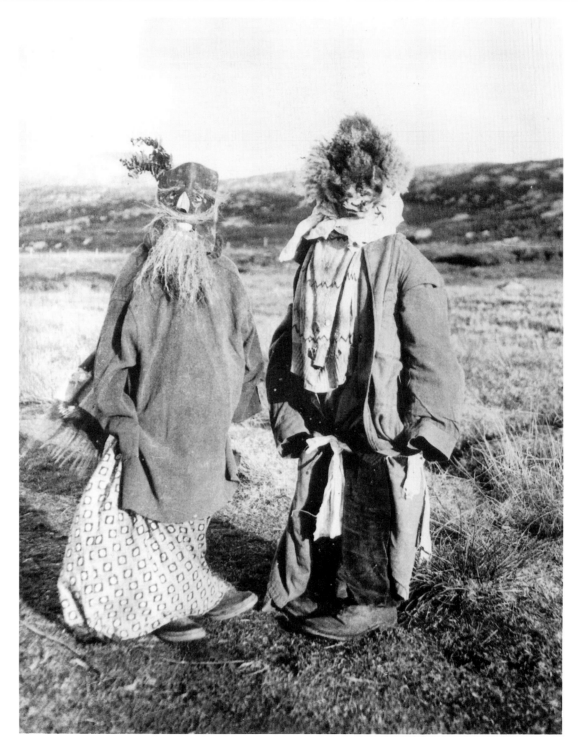

Hogmanay straw-clad guisers on the Island of Fetlar, Shetland continuing a long tradition, once the province of adult men only, in the early 1900s.

Thomas Edmondston writing in the 1860s noted:

'Straw suits are still, in some parts of the Shetland Islands, worn by the peasantry in order to disguise themselves when going from house to house at Hallowmas or Martinmas, and at Christmas. Those disguised are sometimes termed ...'gyzarts', and also in some localities 'skeklers'...The straw helmet is usually ornamented with long streamers of ribbons of different colours. One of the pieces surrounds the neck and covers the shoulders, the larger covers the middle, and the narrow bits are anklets. The face is covered partially with a coloured handkerchief. The maskers go from house to house, and if possible accompanied by a fiddler, performing the most grotesque dances, expecting a dram or small gratuity. The custom is fast dying out.'

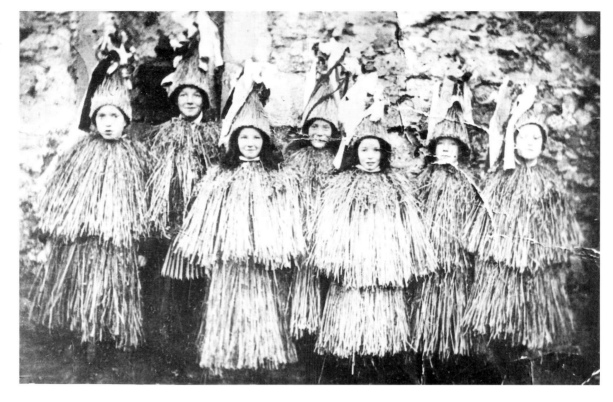

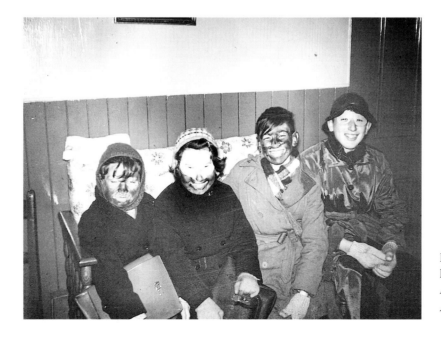

Hogmanay guisers sitting in the kitchen of Brownhill farm, Auchterless, Aberdeenshire in 1959.
Alexander Fenton, NMS

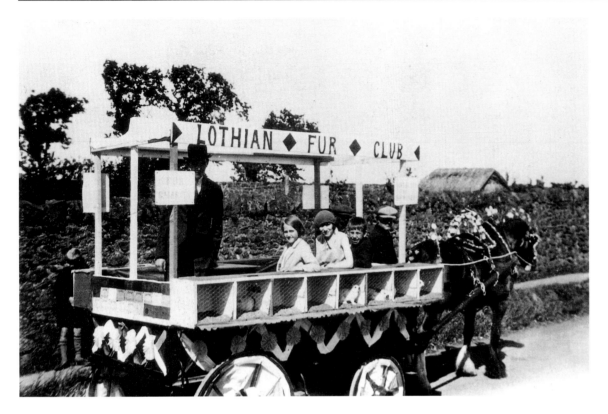

Members of the Lothian Fur Club touring East Lothian 'fur charity' in 1932-3. The float was the Bass Rock Farm cart, from North Berwick. It had been entered into the annual Edinburgh Royal Infirmary fund-raising fete. The farm's head poultryman, Robert Watson, is standing in the cart with his daughter Rena, Jessie Lamont and his son. The rabbits belonged to Jessie's sister, Nan, a dairymaid who ran the Lothian Fur Club - a pelt club which showed their rabbits.

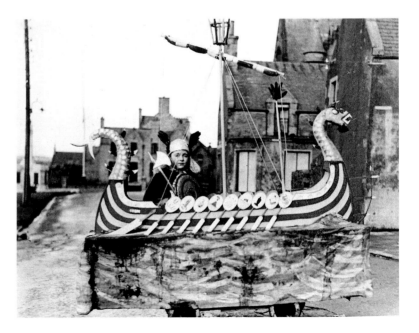

The Junior Jarl aboard his galley in Lerwick during Shetland's annual Up-Helly-Aa new year fire festival, held on the last Tuesday of January. In Lerwick, neither senior nor junior galley is built to be seaworthy, and both are burnt on land.

J Peterson

Guests, including Princesses
Elizabeth and Margaret Rose at the
Master of Carnegie's 8th birthday
party at Elsick House,
Kincardineshire on 24 September
1937.
Laing's Studios.

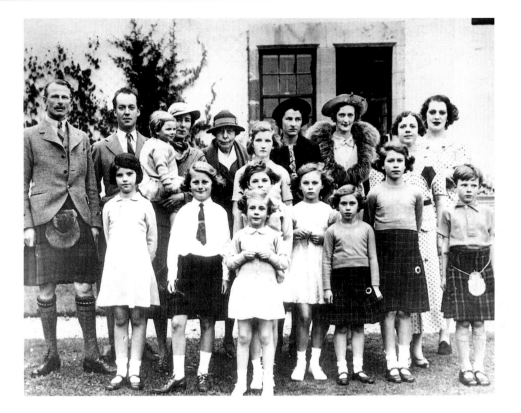

Assisted by her attendants Gracie
Graham enters her carriage with great
dignity after her crowning ceremony
as Breich and Woodmuir Gala
Queen, Midlothian, in the 1920s.

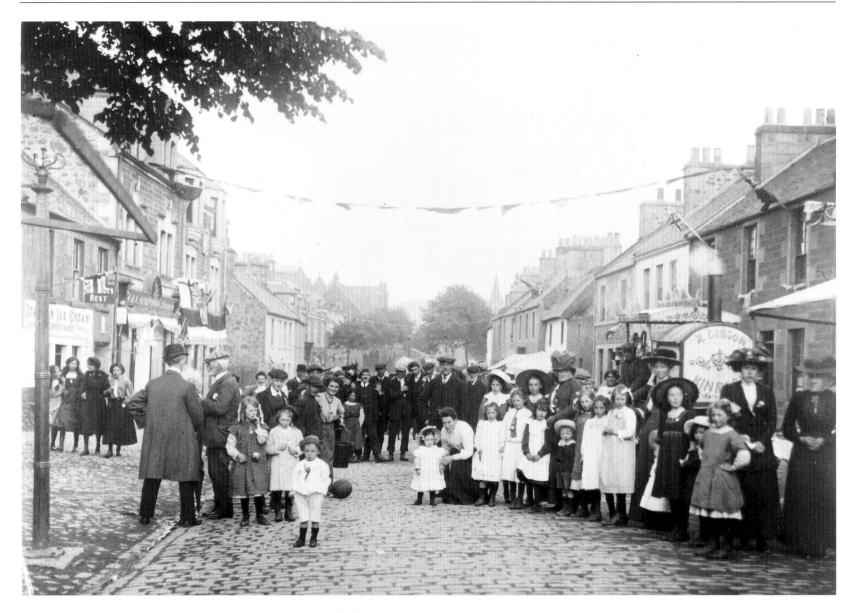

Celebrating the Coronation of
Edward I and VII at Newburgh, Fife
in 1902. Most eyes are fixed on the
photographer, including those of the
little girl who seems to have toffee
from her toffee apple stuck in her
teeth.

Feeding the ducks, with pennies presumably, at a stall in St Andrews, Fife, during the town's annual Lammas Fair in August 1948.
Norman Brown & Co

Tucking into candy floss on Portobello promenade, Edinburgh, c1965. How much can one boy eat?
John MacKay

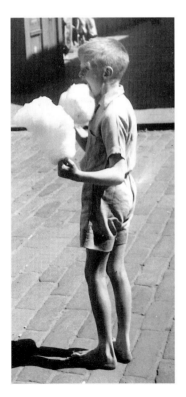

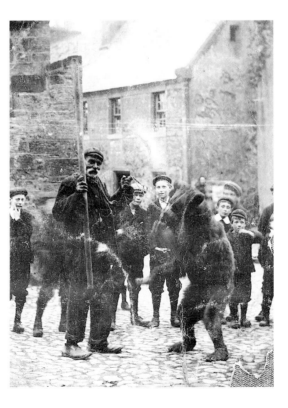

A muzzled dancing bear, photographed in front of his grocer's shop by Andrew Venters of Falkland, Fife in 1905. The worried-looking little boy on the right with a finger in his mouth is William Anderson.
Andrew Venters

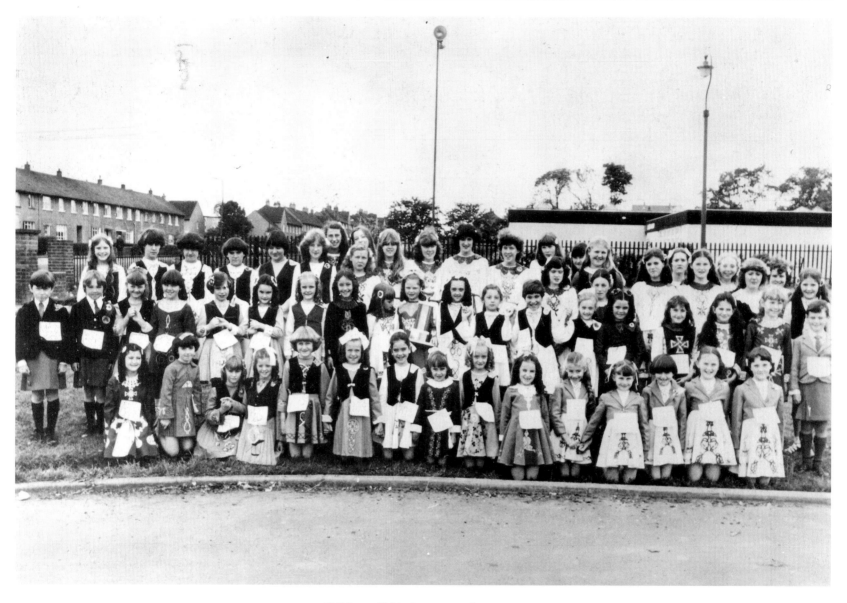

Children of Irish descent continue
the tradition of Irish dancing in View
Park, Uddingston, Lanarkshire on 29
August 1980, during the town's
annual Columba Feis. The sport is
apparently an almost exclusively
female hobby.

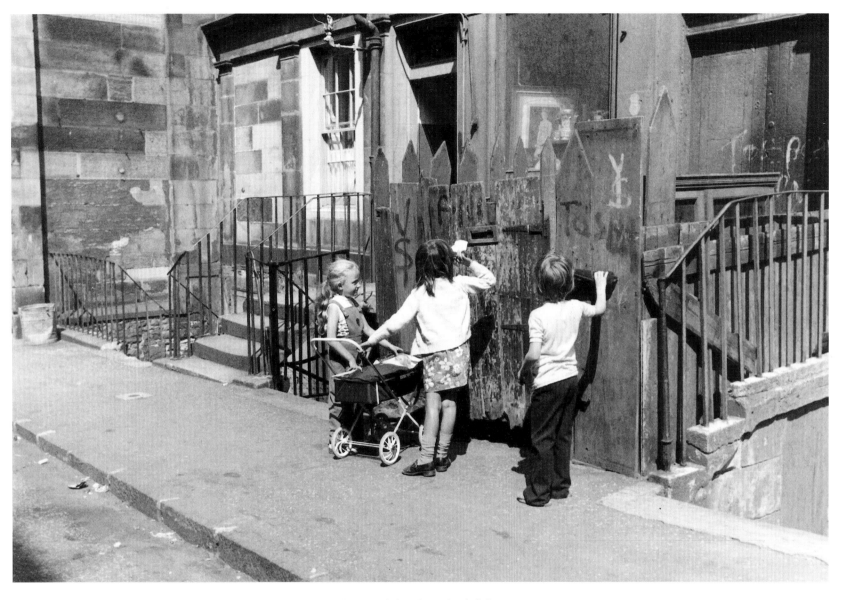

Exploring whilst taking the doll for a
walk in Stockbridge, Edinburgh in
1973.
Gavin Sprott, NMS

Bibliography

General reference

BOYD, Kenneth M. *Scottish church attitudes to sex, marriage and the family 1850-1914*. 1980

CHAMBERS, R.. *Popular Rhymes of Scotland*. 1841

CHECKLAND, Olive. *Philanthropy in Victorian Scotland*. 1980

FERGUSON, T D. *Scottish social welfare 1864-1914*. 1958

FINDLAY, Ian R. *Education in Scotland*. 1973

GLASGOW (Third Statistical Account of Scotland). 1958

HARRIS, Paul. *Aberdeen at War*. 1987

INGLIS, R. *The Children's War*. 1989

KING, Elspeth. *Scotland Sober and Free*. 1979

MACDOUGALL, Ian. *Labour in Scotland (A Pictorial History)*. 1985

Not Just Haggis. 1986

RITCHIE, James T R. *Golden City*. 1965

RITCHIE, James T R.*The Singing Street*. 1951

SCOTLAND, James. *The History of Scottish Education*, vol 2. 1969

SMOUT, T C. *A Century of the Scottish People*. 1986

Memoirs and reminiscences

BLAIR, Anna. *Tea at Miss Cranston's*. 1985

BLAIR, Anna. *More tea at Miss Cranston's*. 1991

BLAIR, Anna. *Croft and Creel (coastal memories 1880-1950)*. 1987

CAMPBELL, Duncan. *Reminiscences of an Octogenarian Highlander*. 1910

FALEY, Jean. *Up oor Close*. 1990

FRASER, D. *The Christian Watt papers (1883-1923)*.1983

HANLEY, Cliff. *Dancing in the Streets*. 1958

KAMM, A and A Lean (eds). *A Scottish Childhood (70 Famous Scots Remember)*. 1985

KAY, Billy (ed). *Odyssey*, 2 vols. 1980, 1982

KESSON, Jessie. *The White Bird Passes*. 1958

LOTHIAN REGIONAL COUNCIL DEPT OF SOCIAL WORK. *Greenlea Old People's Home. A Brief History*.

MCLEVY, James. *Curiosities of Crime in Edinburgh*. 1861

MITCHELL, Ann. *The People of Calton Hill*. 1993

SILLAR, Eleanor. *Edinburgh's Child*. 1961

TOLLCROSS LOCAL HISTORY PROJECT. *Waters under the Bridge*. 1990